Ahlwat has a sharp awareness of form, colour and texture. This book shows his ways of looking at the natural world around him with a new and heightened awareness. Through the written word and his painterly images, he has set out to capture this newfound rapture with the natural world.

ADRIAN SHAUGHNESSY

In his lovely new book, Ahlawat draws our attention away from the modern flood of information and brings it back to the gifts the natural world provides. His probing texts work seamlessly with his sumptuous artwork.

PETER MENDELSUND

SLOW *is*
BEAUTIFUL

SLOW *is*
BEAUTIFUL

*The Ultimate Art Journal
for Mindful Living
Through Nature*

Foreword by
RANJIT HOSKOTE

AHLAWAT GUNJAN

PENGUIN
STUDIO

An imprint of Penguin Random House

STUDIO

USA | Canada | UK | Ireland | Australia
New Zealand | India | South Africa | China

Studio is part of the Penguin Random House group of companies
whose addresses can be found at global.penguinrandomhouse.com

Published by Penguin Random House India Pvt. Ltd
4th Floor, Capital Tower 1, MG Road,
Gurugram 122 002, Haryana, India

Penguin
Random House
India

First published in Studio by Penguin Random House India in 2023

ISBN 9780670095261

Typeset in Macklin Slab
Printed at Replika Press Pvt. Ltd, India

www.penguin.co.in

for

MY FRIEND,
*whom I loved abundantly
and lost abruptly*

MUMMY AND DADDY

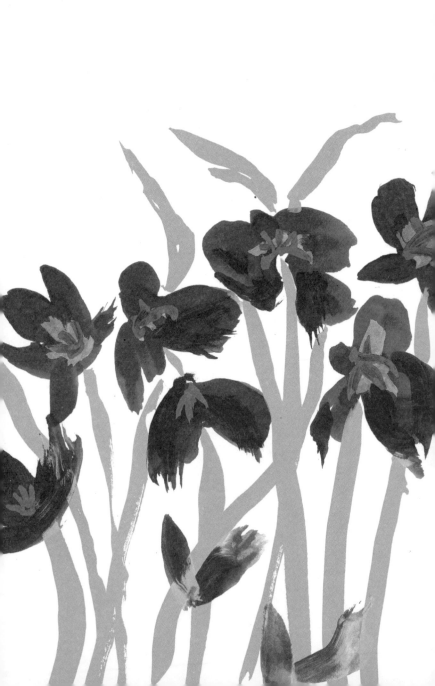

'The gardens that have graced this mortal Eden of ours are
the best evidence of humanity's reason for being on Earth.
Where history unleashes its destructive and annihilating
forces, we must, if we are to preserve our sanity, to say
nothing of our humanity, work against and in spite of them.
We must seek out healing or redemptive forces and allow
them to grow in us. That is what it means to tend our garden
... *Notre jardin* is never a garden of merely private concerns
into which one escapes from the real; it is that plot of soil on
the earth, within the self, or amid the social collective, where
the cultural, ethical, and civic virtues that save reality from
its own worst impulses are cultivated. Those virtues are
always ours.'

—ROBERT POGUE HARRISON,
Gardens: An Essay on the Human Condition[1]

Walk through a garden set in the heart of a city, or through
a forest. Or even along a stretch of greenery where nature
has regained the upper hand over engineering and civic
objectives. In each case, you will find yourself breathing a

[1]Robert Pogue Harrison, *Gardens: An Essay on the Human Condition*
(Chicago and London: The University of Chicago Press, 2008), p. x.

fresher, immeasurably more capacious and regenerating air than your embattled lungs encounter in everyday life. This is the air that animates Ahlawat Gunjan's beautiful dialogue of image and text, *Slow is Beautiful*.

I have had the great pleasure of working with Gunjan, and getting to know him, through our happy collaboration across several adventures in publishing; he has designed some of the most memorable covers that my books have enjoyed. Imagine my delight when, in early 2020, he called to tell me that he was working on a book of his own. High time, too, I thought. Having poured his energies into the publications of friends and colleagues, he was at last putting together one of his own—articulating his thoughts, feelings and sensations at a time when these were all acutely present to us, as we confronted the imposed claustrophobia of the lockdown, individually and collectively.

Slow is Beautiful speaks for us all. It is a testament to the paradoxical reality that, during our Covidocene confinement, we became radically responsive to the environment from which we had been summarily cut off. However momentarily, we recognized that the world had been re-enchanted. We became aware, once again, of birdsong. We noticed that animals were reclaiming the deserted carriageways and byways of our cities; that butterflies were back. We saw that the waters were cleaner, the skies bluer, the earth breathing again in relief, untroubled by the toxic apex predator that has long masqueraded as the sovereign and omniscient species, humankind. Even a few months of that apex predator's absence, and the withdrawal of its brutalizing activities and

extractive technologies, and nature had reasserted itself. Across the planet, we experienced the manner in which nature has healed and replenished itself in glorious measure in those isolated, unlikely parts of the earth that have, for fortuitous reasons, been spared the human presence: the Demilitarized Zone (DMZ) between the two Koreas, and the Chernobyl Exclusion Zone, where plant life and diverse animal and bird species have returned, and now flourish.

As Gunjan reminds us, he has never been cut away from the life of the soil. In recent years, he has spent a lot of time in his family home, with its adjoining farmland and canal, on the outskirts of Meerut, in northern India. It is an intensely familiar environment, with its rhythms of sowing and reaping, cropping and gleaning, harvest and fallow. Trained at the National Institute of Design, Ahmedabad, and the Glasgow School of Art, Gunjan has long ago internalized the reflexes of the designer—and yet, as he traversed garden, farmland, and canal zone during 2020-2021, he found himself yielding up his emphasis on precise control and geared poise. Instead, he opened up his consciousness to receive impulses that may at first have appeared unruly, yet soon revealed their secret rhythms and patterns.

The pages of this exquisite journal are sumptuous with images of flowers, luscious evocations of fruit: these are not exemplars of the classical still life or *nature morte*; rather, they celebrate the vibrancy of the natural world as it comes to bud and bloom. Like many artists before him—Georgia O'Keefe, Odilon Redon, and John Berger come to mind at once—Ahlawat is fascinated by flowers in their outright, explicitly gorgeous avatars; and also by flowers

in their shadowed mystery. The floral is not a token of the decorative to these artists; rather, it is the covenant between nature and humankind, by which nature promises humankind the blessing of abundance.

In Ahlawat's images, we come upon little infinities of leaf and flower, pistil and stamen; the cycles of nature as they go through the phases of emergence, ripeness, decay, and regeneration. How unsurprising, then, that the garden should have suggested itself to many civilizations as a metaphor: the sacred *hortus conclusus* or closed garden, signifying the Virgin Mary's sacrosanct character in Catholic art; the *bagh-e bahisht* or paradise garden in the Persian tradition, usually laid out in a formal, elegant manner; and the *vatika* in Sanskrit lore, part grove and part orchard, shuttling between stately grandeur and wild fecundity across the seasons.

Slow is Beautiful is a pensive book, with its interplay of 'bloom and gloom', in Ahlawat's phrase. As we read, view, and savour it, we observe the confrontation between the shadow of extinction and the promise of resilience; and, between these extremes, we must shape our lives. Responding once again to the presence of creepers and flowers, leaves, and buds, Gunjan found himself asking what it truly means to return to nature—and not merely as a fashionable transformation of lifestyle, attended by organic diets in a comfortable rural retreat. How do we make the transition from contemporary urban existence, which tends to be profoundly alienated from the natural world, and approach nature in the spirit of pupils or apprentices, studying the processes by which nature heals, cares, makes

that which is wounded sound and whole again? How might we emulate the garden that gives generously of itself, unasked; how might we emulate the patient gardener, with her trust in the living materiality of wet soil, the weave of roots, the claims of leaf and branch?

In the brief passage that serves this foreword as an epigraph, the literary scholar Robert Pogue Harrison shows us how our garden is not an escape from the real, but a venue where we may cultivate the virtues that will sustain us against barbarity: it restores us to ourselves and our proper purpose as denizens of the polis and the cosmos. Ahlawat, too, as he meditates on the garden, points us in the direction of an ethic that plants teach us. This ethic is perhaps best glossed by the contemporary philosopher Michael Marder in his brilliantly provocative and fruitful book, *The Philosopher's Plant:*

> Plant world puts itself in the service of life ... In what it is and what it does, it is *for* the other while remaining itself. That is what flowering-with at last conveys: finding one's conditions for flourishing in the other and dedicating oneself to the other's flourishing are not synonymous with losing oneself ... Only in a pathologically narcissistic culture will living for the sake of the other be conflated with self-sacrifice. Giving [of] oneself is not self-abnegating but sharing.[2]

The garden summons us to be our highest selves; like Rilke's ancient torso of Apollo, it insists, however gently, that we must change our lives.

[2]Michael Marder, *The Philosopher's Plant: An Intellectual Herbarium* (New York: Columbia University Press, 2014), pp. 221-222.

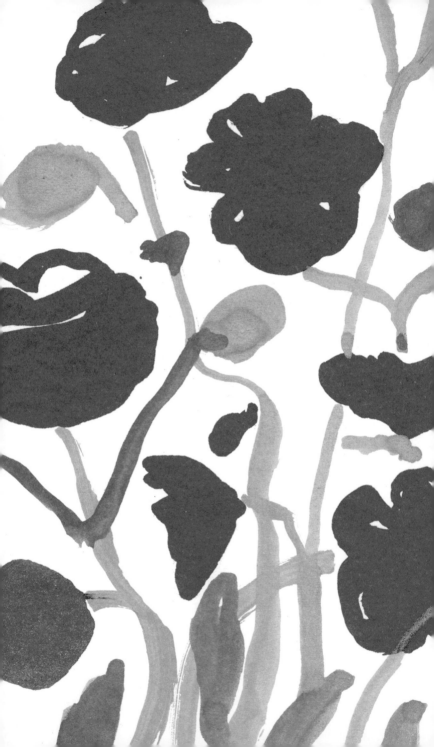

'*On ne voit bien qu'avec le cœur.*
L'essentiel est invisible pour les yeux.'
[We see better with our heart.
The essential is invisible to the eyes.]
—ANTOINE DE SAINT-EXUPÉRY in *Le Petit Prince*
(*The Little Prince*)

From the moment we open our eyes in the morning till we
hit the bed in the evening, we are constantly perceiving the
world through our eyes. Today we live in a world in which
we are constantly bombarded with visual stimuli and where
we have too little time to process that information and
make sense of it. Picture-perfect moments captured on our
phones remain on the device or are shared and instantly
forgotten. Visual fatigue and the eventual feeling of being
overwhelmed are almost a daily experience for most. In
this dense world of images, is it possible to filter snapshots,
and to save them in our memory and not (just) digitally?
As early as the twentieth century, psychologists Max
Wertheimer, Kurt Koffka and Wolfgang Kohler, the founders

of the Gestalt theory, studied the ways in which we process chaotic visual stimuli, and create meaning and order in a disorderly, unruly world. The brain and eyes work together to comprehend all the information, to recognize as well as categorize, and then to retrieve when needed.

Have you ever wondered how much of it stays with you? Would you like some of it to stay longer with you? If yes, you need to transform your ways of looking into ways of seeing. In my opinion, when 'looking', we engage in a passive way with the subject, whereas when 'seeing', we actively engage with our head and heart at the same time. The latter might prove to be more pleasurable as the visual experience and exploration stays with us for longer.

How do artists see, perceive and imagine with clarity and simplicity? Do they use any specialized techniques and tools to differentiate the various ways they see?

To refine our skills and progress from simply looking to seeing, we can take the help of several treatises. One such is John Berger's *Ways of Seeing*, which condenses aesthetics and politics while teaching us to engage with art at the same time being mindful of the impact that visual arts has on society. It can help us to answer the question: In times when there is a barrage of images and the threat of inevitable visual fatigue looms large, how can we, as creative individuals, learn to *see*?

Being an artist myself, I feel slowing down is the first step in mindful seeing. Slowing down allows us to cut the noise within and to absorb the world around us better. We hear

and see with more clarity when there are fewer internal distractions and this lets us engage all our senses to observe the finer nuances of our environment. A walk in a park without headphones means noticing the chirping of birds, the hum of insects, the texture of the grass, the intermingled scent of flowers and foliage—this may sound like a cliché but it does help us enter a state of greater concentration. It is then that we are in a state of flow, and in this moment of connection, we perceive what is in front of us with greater clarity, thus being able to translate it as artists. It is only on the slow-moving vehicle that you are able to see and absorb the surroundings to enjoy the journey, otherwise everything rapidly passes us by as if in a haze.

The next step is to let go of any notion of familiarity with the subject. In fact, familiarity can dull one's senses. When we observe the world with a fresh pair of eyes, even the most mundane things have the potential to surprise and, even better, to delight! One looks more intently at everything, whether it is a tree, a person, or a feeling! I firmly believe that there is no right or wrong way of creating art. For me, it's your voice, your imprint, which is unique and yours alone. Just like each of us has a distinct handwriting, we also have our own ways and style of making art. When you write, your letters are bound to look different from anyone else's and we accept this without resistance. Then why not your art? Your style may not be realistic or abstract or figurative, but it is, after all, your style of seeing and representing. Let the apple not look like an apple. Of course, if you like other styles, you can always work towards finding your voice in that direction—it's as easy (or difficult) as learning cursive handwriting or calligraphy!

Slowing down and letting go are also the perfect ways to start your creative journey. It's time to suspend any judgements and be free of expectations!

And finally, our aim is to harness the power of making. By learning to see and then practising without any self-consciousness, creating any form of work using your hands, heart, and head will leave you with an everlasting impression and knowledge that time can't undo. It is about going back to the basics: do you remember tracing the alphabet, where you were taught to draw letters? It may seem very simple or mundane, but it is a great exercise for registration. Doing it over and over again, it naturally becomes muscle memory. Letters are nothing but visual forms that are recorded in a child's memory for the lifetime. In this aspect, practising art is no different from learning to write. The more you engage with art, the more powerfully artistic expression emerges with clarity and conviction. Although there are loads of tools readily available in the market—from brushes, ink pens, and reeds, to charcoal, and crayons—there is a certain joy in creating your own tools. Perhaps you can use a dried branch or a feather as a brush to make quick sketches. Or you could crush leaves to make green paint for your next painting. Creativity lies in the making.

Making images has been the oldest and strongest way to observe, record, remember and visually communicate ideas across centuries—from early cave engravings to Van Gogh, right up to our contemporary times. Advancements in technology have made several tasks easier and faster for humans, but they have also taken away certain strengths

and charms we used to have as individuals. In my view, there was a trade-off: we gained some tools, we lost some tools! Consider this: Do we even remember telephone numbers anymore? Or draw maps to give directions? And how many times do we make that grocery list anymore on a piece of paper? Such examples are endless, and they show how and why we have lost our faculty to draw, paint, and above all make. I'm a huge admirer, believer, and user of technology but as an artist I miss the old ways of doing, noticing, and remembering the world around me, which, I feel, are more experiential and mindful.

My training and experience in visual design allow me to figure out differences in all things artistic down to the most obscure nuances, such as values of the same colour or thickness of the paper. After acquiring two degrees and more than a decade of experience in various fields of design, I can now safely say that it's not merely education or professional training that sensitizes you to your environment; we all are intrinsically blessed to observe and absorb our surroundings. Unfortunately, due to circumstances and conditioning, some of us lose track of this precious gift, this valuable toolkit; some others simply don't know how to channelize it. There are yet others who don't see value in such an outlook because they follow a predetermined template in life. On the other hand, there are creative people with talent who, due to stressful jobs and personal anxieties, are unable to tap into this powerful tool.

Making use of the qualities and properties of seeing, this book invites you to go into nature to slow down, to suspend familiarity and embark on a journey to create with me.

Slow is Beautiful is a creative sojourn to assist and inspire you to step out, to see nature with artistic focus and designerly simplicity. To make those small observations in patterns, textures, colours, hidden forms, and fragrance, and to develop a visual vocabulary of seeing, one that is truly yours!

Through drawings, experimental mark-making with natural elements, and embracing the loose approach, this book will not only help add texture and depth to your artworks, but also bring a fresh perspective to the ways you observe and enjoy nature. In a fresh and transferable way—through figuration and abstraction—and by focusing on simple forms, considered composition, and a limited colour palette, let's begin our journey towards making.

how to use this book

Slow is Beautiful is divided into six sections. In each section, I share ten ideas from my experience in nature, and is assisted by my art and design background. Each idea is supported with a small exercise. You are invited to interpret the exercise in the space provided in whichever form you wish to. These are just suggestions to trigger your attention, and to excite you to take it forward in your own way.

I hope this book will become your companion on your walks, on your commute to work, while cooking a meal or even in the bathroom.

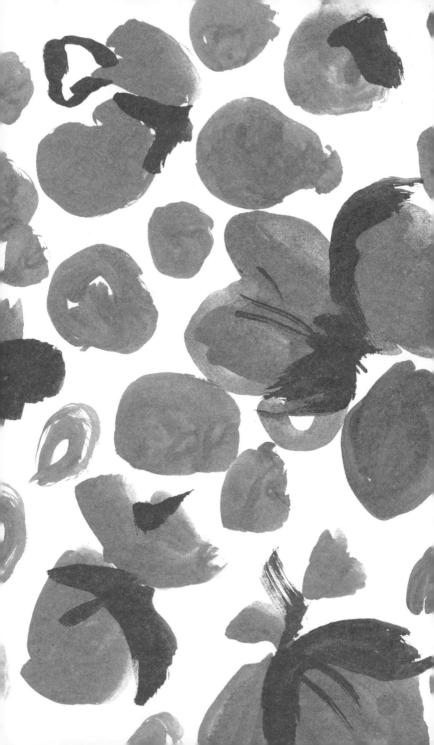

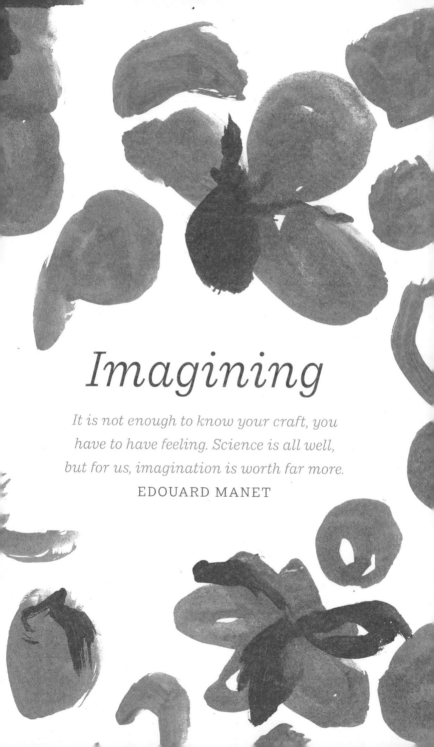

Imagining

It is not enough to know your craft, you have to have feeling. Science is all well, but for us, imagination is worth far more.

EDOUARD MANET

Visuals are created in my mind's heart.
The outcome is just an interpretation of that imagination.

List down aspects you experience when you imagine something. Think of how you integrate your senses while imagining.

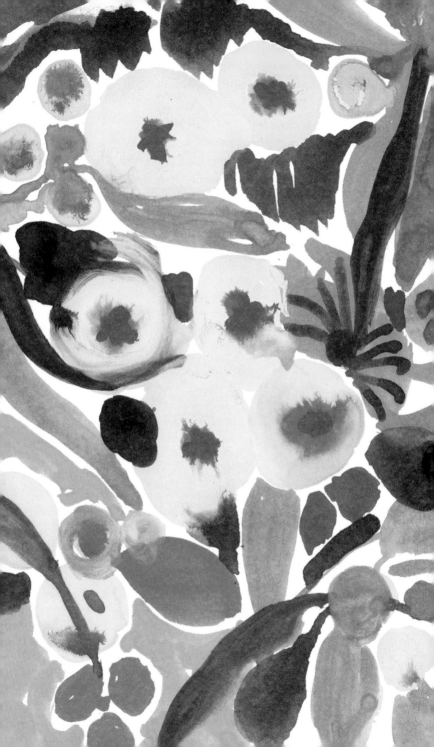

Wilderness is not haphazard. It is nature's careful rendering of abstraction. It is art with its own song and dance for the senses.

Look at leaves, fruits, and trees and see if you notice any kind of abstraction in colour or form. Capture this spirit through your own interpretation!

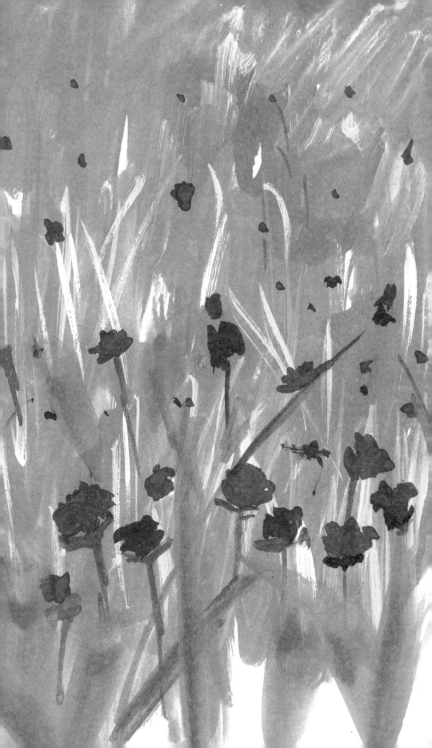

Reflections may seem shaky. They change with time.
With the changing of the Sun, reflections also change.
Is an artist a reflection of their art or is art a reflection
of the artist?

*Try to find a poem on reflections and interpret it in
the space here. Suspend any sense of form or colour.
Just try a free-flowing interpretation using any medium.*

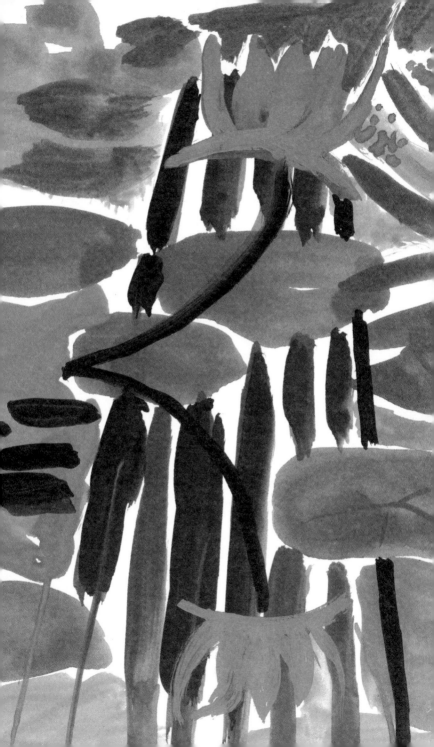

To spread our wings and fly like a bird, don't you think we need to detach ourselves from the weight of worldly pursuits? Revel in the lightness of being.

Make quick five-second sketches of birds in flight and see if you experience the lightness in your marks.

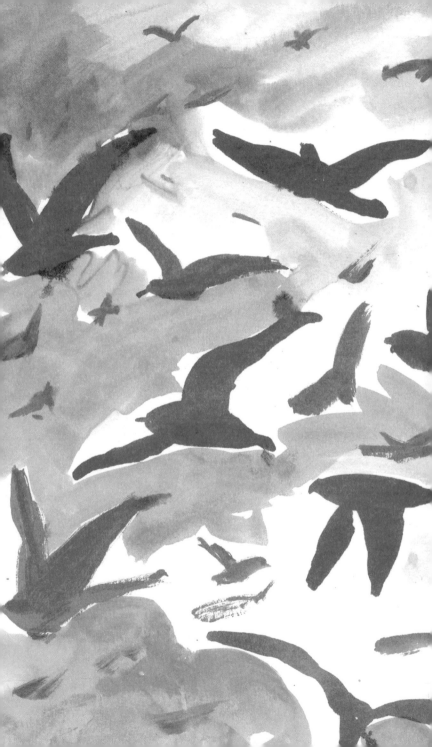

Like flowers and leaves, have you ever tried to dry out time in the memory book? Did it change form or fly off like a bird's feather into future chapters?

Go find a feather and draw a memory with it.

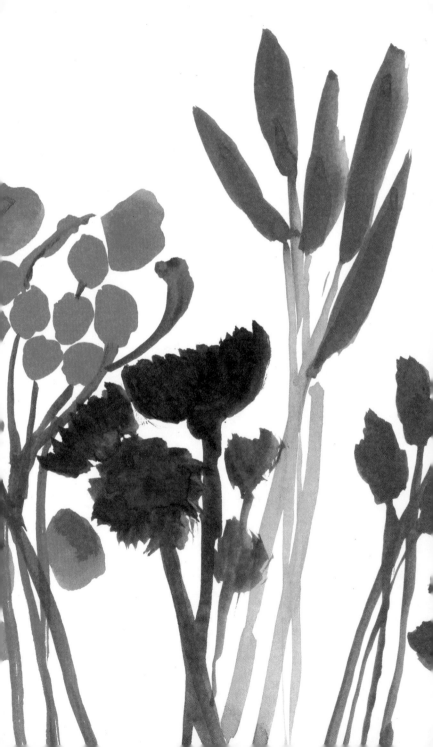

Nature has its very own unique ways of combining colours, from the most contrasting to the most subdued. Painters and, designers have always borrowed colour combinations from nature. And it has always worked. It's endless, with every single one working in perfect harmony and balance.

Think of your favourite art. Draw up a swatch sheet from your memory. Once done, now compare it with the real piece and see the differences and similarities.

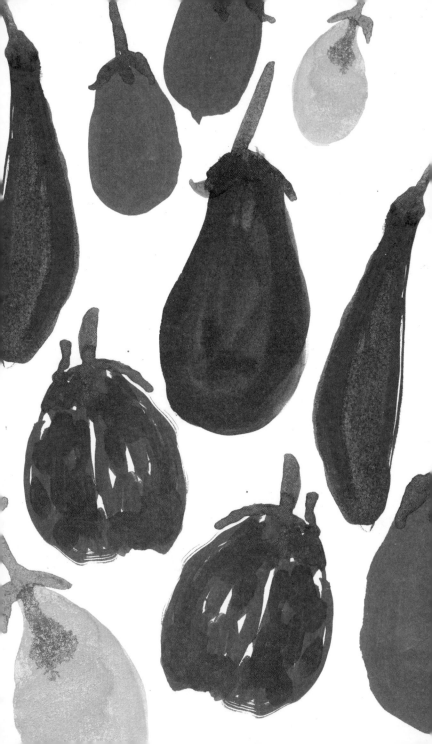

Vapours rising from the lake. Snow covering the ground. Nature has its ways of blurring boundaries to define them. Don't be afraid to step into the haziness of your own creativity to seek clarity and meaning.

In a long horizontal strip, try to explore colour from shade to tint and see all the values one hue can offer.

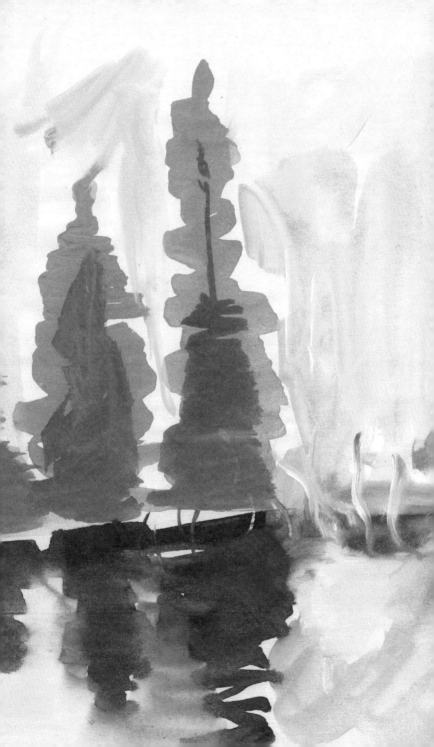

A winter tree, barren and still. Sparrows hopping around the branches, as if a designer trying to assess elements to compose the best possible image of reality. By addition and subtraction, all played in loop. Can nature be both the artist and the art?

Interchanging background and foreground could affect the picture. Try to record one such experience and see the importance of the change.

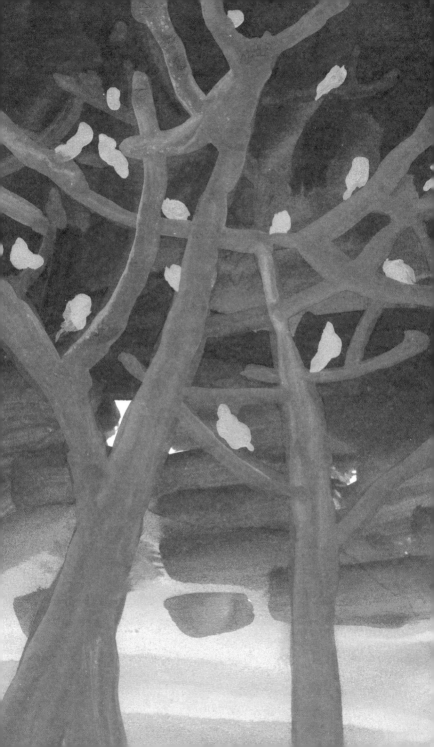

Make your own tools with broken branches, twigs, feathers, tree barks, and stems. You may already be one step closer to nature and your artistic endeavours.

What are the other such tools you can think of? Use one of them to make something.

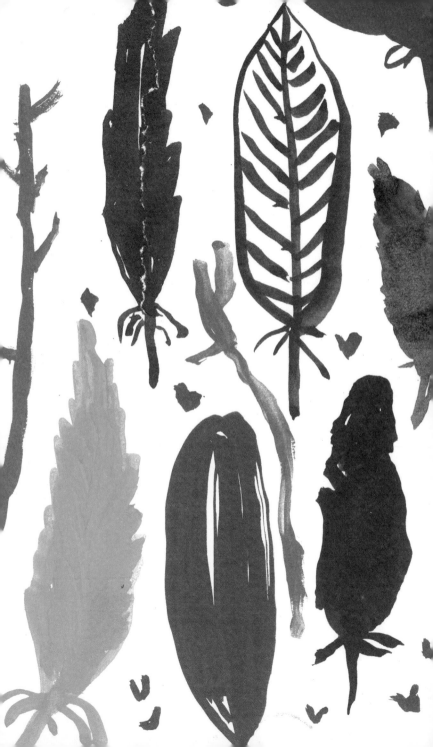

Nature understands the science and art of simplicity. Nothing is decorated in nature, it's all thoughtfully designed. And with this design, it decorates everything. How does a night sky know where to put the stars?

Take any photograph and try to simplify the forms to the bare minimum. Observe if the reduced visual speaks with same clarity or not. Consider how logos are created by simplifying forms!

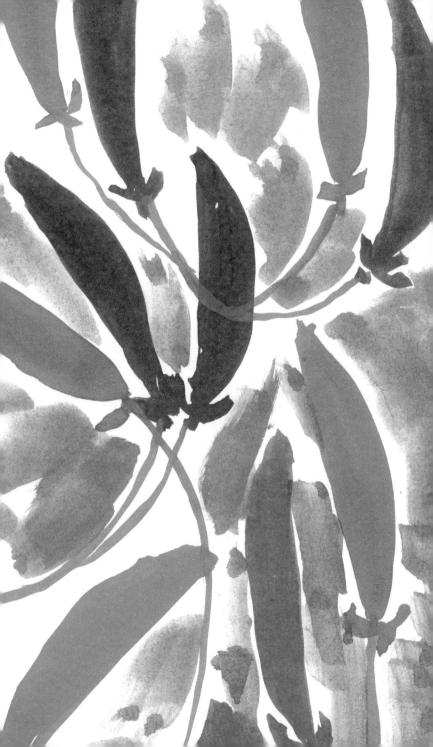

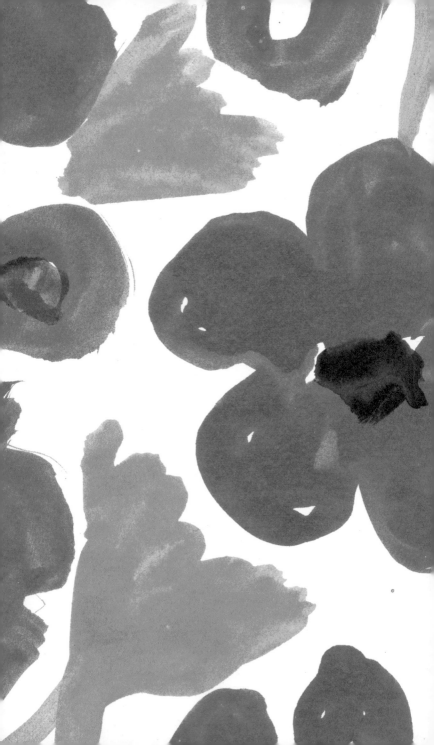

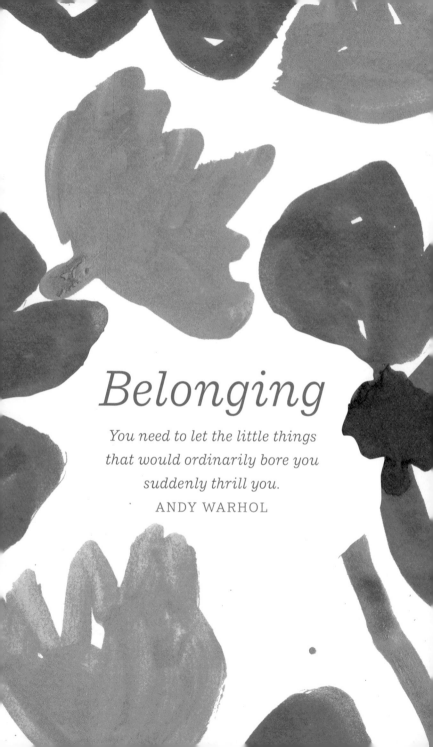

Belonging

*You need to let the little things
that would ordinarily bore you
suddenly thrill you.*
ANDY WARHOL

New leaves, flowers and branches are a testament that they are connected to the roots. Along with the physical support, do you feel there is a strong emotional bond too? Of inheritance and promise. Like generations supporting each other.

Look around and observe the angles and the strength with which leaves and flowers are connected to the branches.

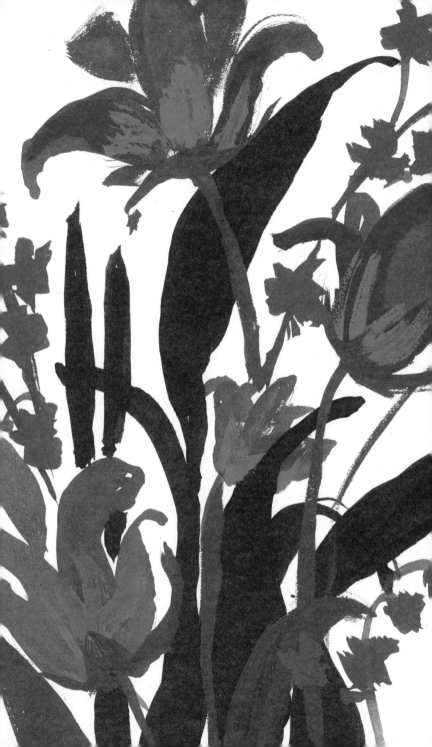

Like everything else in nature, shadows are interconnected too. A shadow is fearless. A form that is slow and moves onto any surface without fear. Scared neither of its ever-changing visual personality nor of spaces to climb upon. It just stretches from origin to imagination and yet remains tied to the source.

Take a few photos of shadows and paste them here to understand their character.

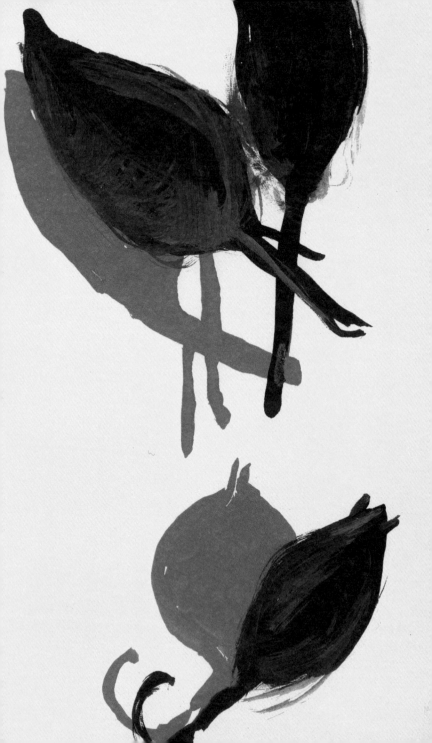

Magenta bougainvillea hugging an almost yellow neem tree.
Do you think humans learnt hugging from nature?
A hug to unify colour and form. A sense of togetherness.

Go and hug someone dear today.
Come back and draw how you feel about it!

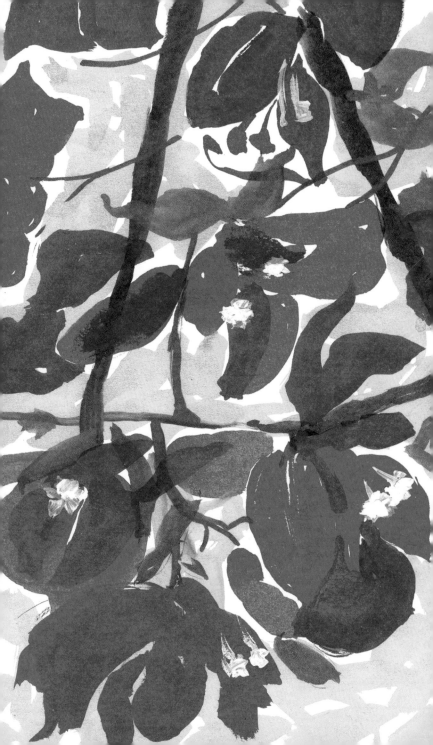

Like an artist, a blooming flower reflects its inner beauty.
To be beautiful from outside, do you think the inside
needs to be beautiful too? Makes me wonder about
the internal beauty of a tree. A cloud.

*Cut open a pomegranate. Make several drawings to note the
small partitions/walls and the geometry of the seeds held
together. Nature seems to understand packing at its best!*

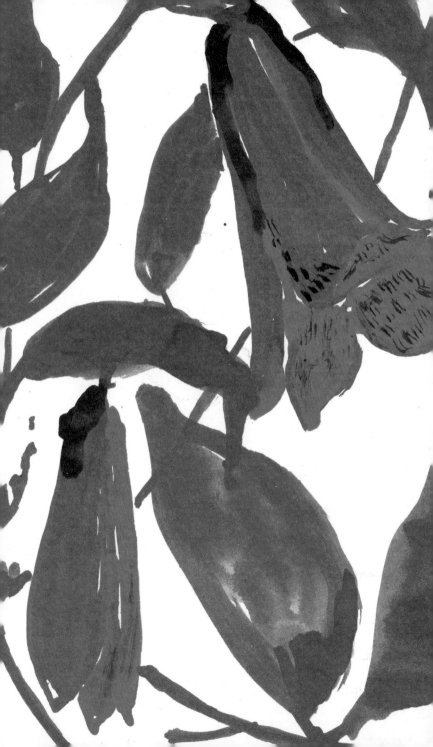

Do you think flowers are little artists in themselves?
They seem to orchestrate unique colour combinations
through seasons. Is there an invisible joy in their hearts?
To bloom, to sing, and to dance.

*Cut coloured swatches from newspapers and magazines
(better still, tear them with your hands) and create a flower
using the paper collage technique. You may wish to check
online how others have attempted a collage, if you need a
starting point.*

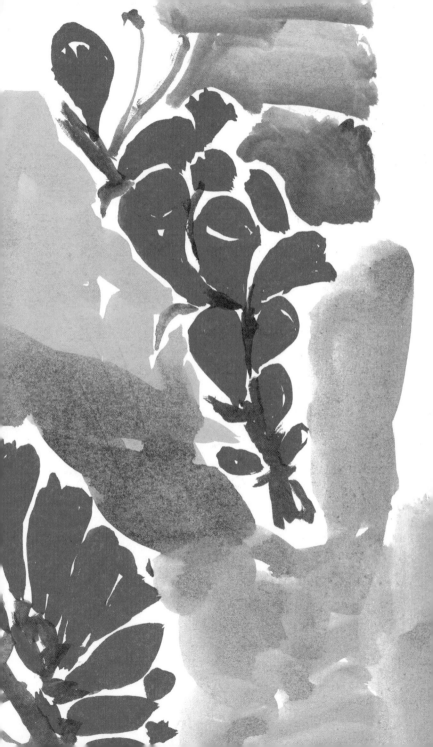

Real connections don't die with distance. Space and time tie them together. Spring after autumn. Stars around the moon. All are connected because of the spaces between them. Don't you think connections blossom in such spaces too?

Can you list a few examples of such connections from nature?

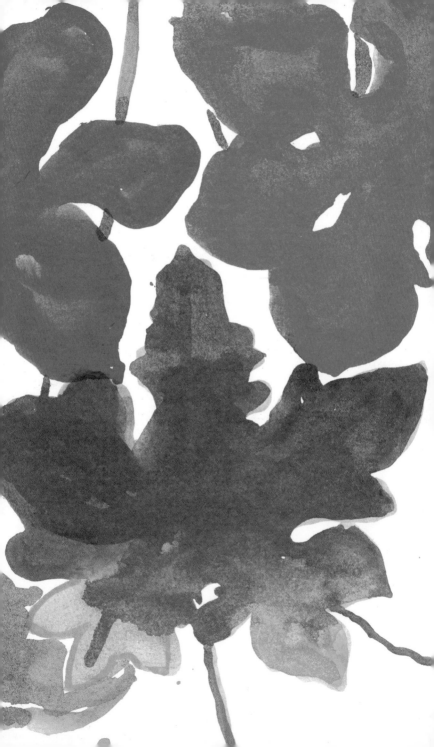

Some friendships are like water lilies. Everything happens under the surface and it is the flower of friendship that is visible above. Do you have any such real connections in life?

Look at the underwater life. Observe the circular geometry of ripples and varying shades in it.

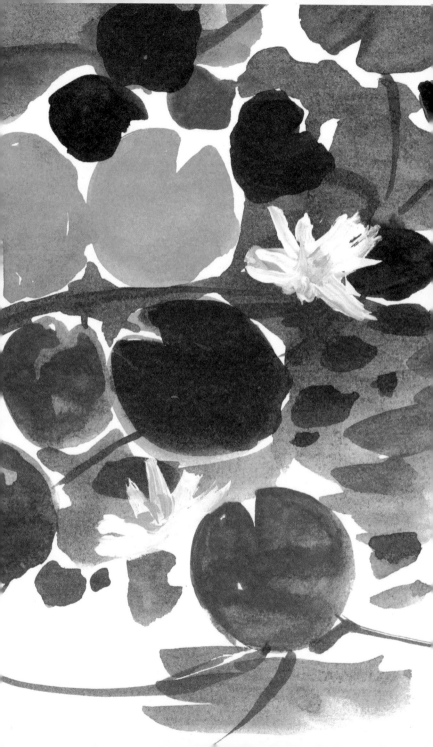

Connections can be strong, beautiful, and of varying nature. How are leaves joined to the branch? How are petals joined with one another, and how are branches connected to the tree? Diagonal, opposite, circular!

Try representing these connections through abstract forms and see if you can still retain the character.

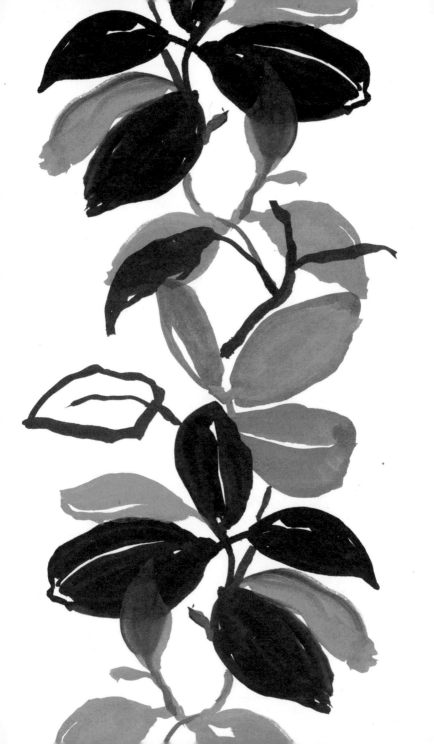

Fallen flowers, leaves and branches are memories and
memorabilia that you carry. On long or short walks.
To cherish and add. Do these collected lives add to
your scrapbook of memories?

*Try to prepare a few compositions using collected leaves
and flowers. By grouping them in similar-looking forms
and at varying distances. Then, observe the strength in the
compositions. Feel free to move them till you are satisfied.*

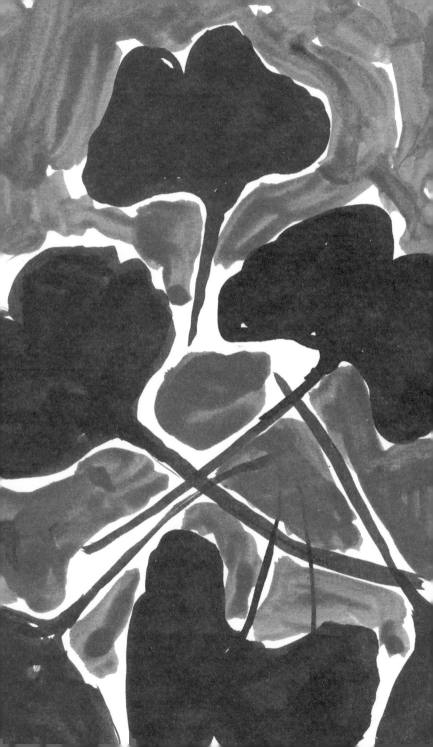

Nature doesn't ask for appreciation or acknowledgement. It just blooms in its simplicity and grandeur. How often do you appreciate others? What is the feeling like?

What aspects of your being do you appreciate, however small they may seem, when alone?

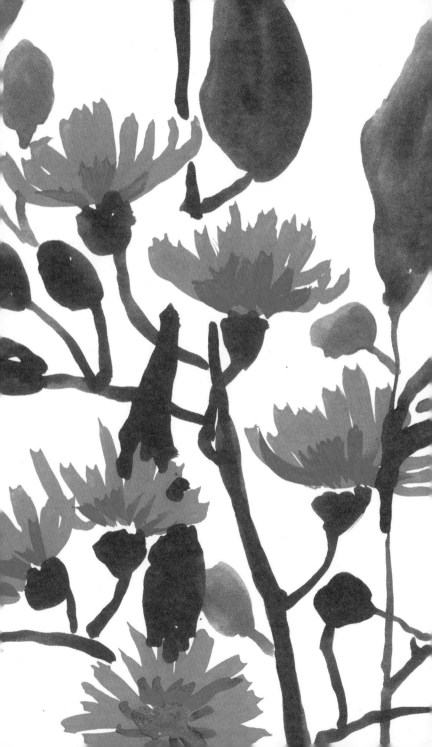

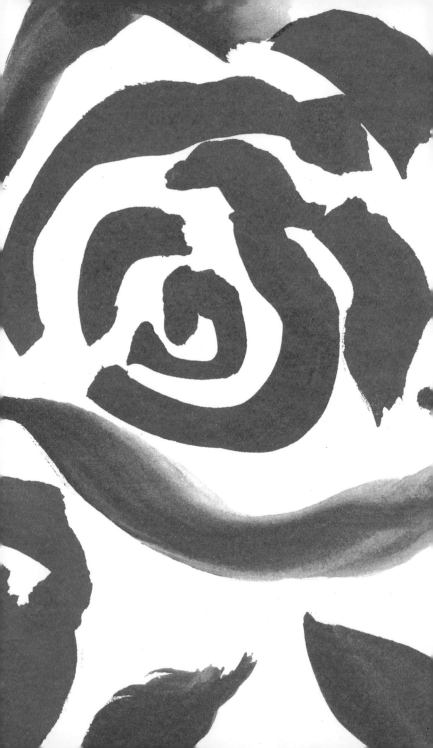

Being

*Art is a way of
recognizing onself.*
LOUISE BOURGEOIS

A memory is like a pressed flower in a book.
You can take the life out of it, but the beauty in the
stillness of the remains perseveres. A compressed form
of time. What stays more with you? The first or the last look?

Go for a walk, collect the fallen flowers, and paste them here.
With time, they may become the memory of this day!

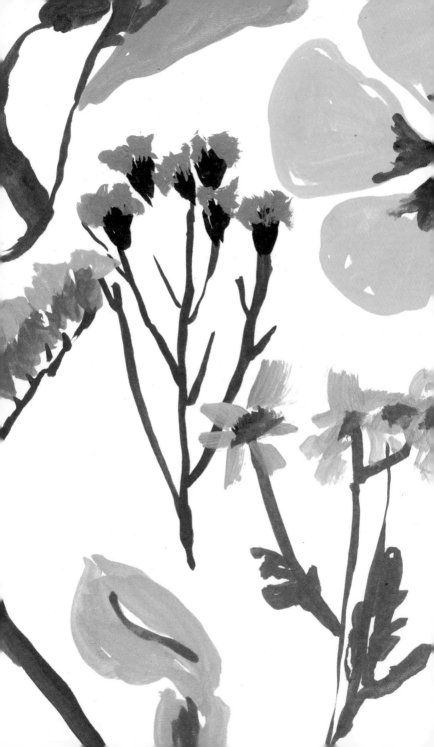

A walk in the woods can be as lonely as the woods themselves. Let the sensations, emotions, a keen pair of eyes, and fresh breeze be the tools in your painting kit, while you walk mindfully.

What is your relationship with loneliness? Define it for yourself in a few lines or a sketch. From reality or memory. And see if the relationship changes.

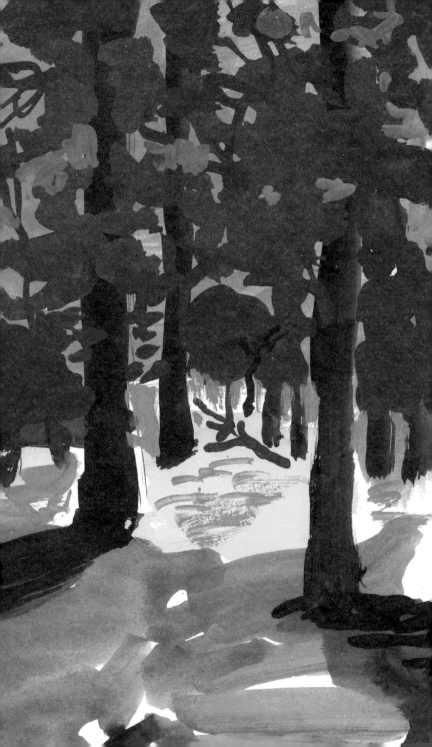

Collect memories like flowers and leaves which you want in the vase of your life. With time, they will wither. But at least you would have enjoyed a few days in good company.

Make a flower bouquet today and try to paint an image of it. One by looking at it and another by just remembering, after the flowers have dried.

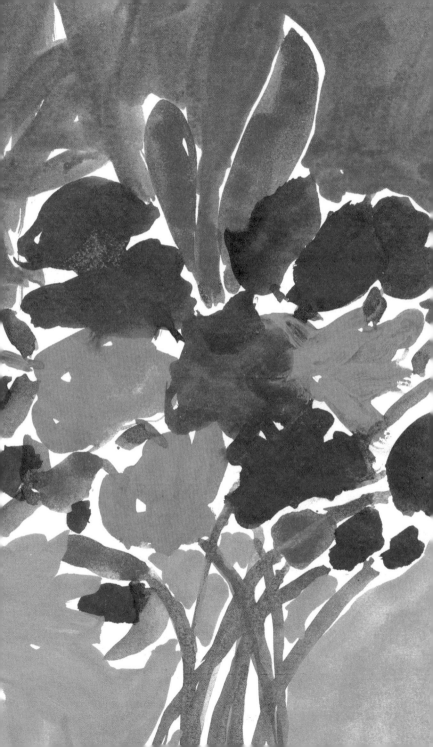

Sometimes, you don't have to do anything. Not doing
anything is also doing a lot. Suspend the thinking. Suspend
the sense-making. Give time to the soil of your mind to regain
its fertility. Does the river flow because it must?
Or does it flow because it is?

Take a line for a walk in the space below!

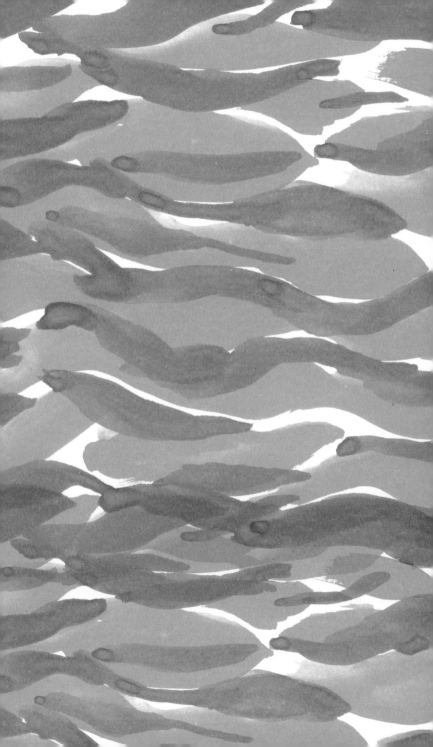

When the roots are deep, there is no reason to be afraid. Trees trust that the Sun will offer sunlight, rain will bring them water, all without moving. Such is trust, for you and me to seek.

How do you define trust? Do you borrow examples from nature? If so, what are they?

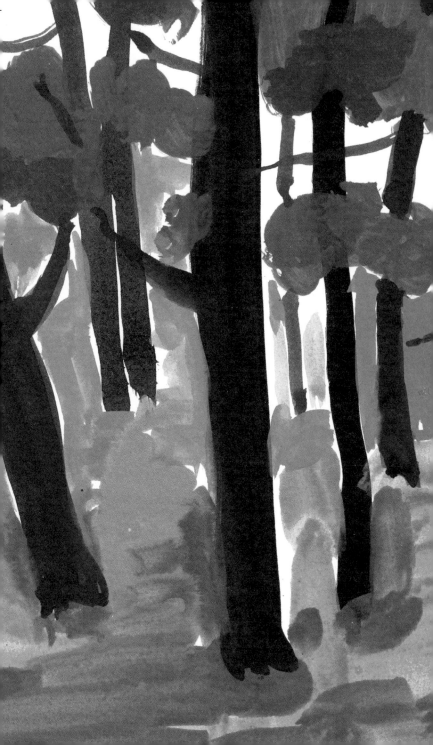

When flowers and leaves fall, do you think they fall with a smile? Knowing they wouldn't be able to get up like you and me? Next time you fall, remember you are blessed to be able to dust off and move on again!

Collect fallen flowers and leaves and stick them in the space here. Now imagine what had been their place and complete their life by drawing the stem/leaf around them.

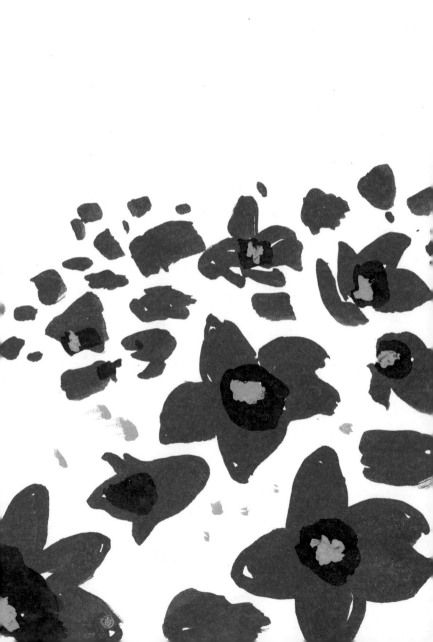

Is a flower as beautiful from the inside as it is from the outside? Is an artist's work a reflection of their inner soul?

Try to trace the texture of tree bark and see how it speaks to you. Does it tell a tale of its inner life? Make your own interpretation in a few lines.

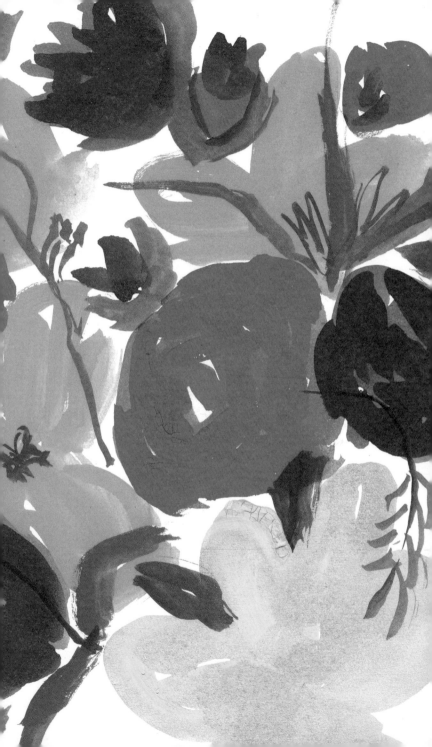

Let your paint and imagination flow like a river.
Figuring its own course. Let there be a mess like a storm.
From this will emerge clarity and form.
A voice that will be yours. And only yours.

*Make a list of things you messed up in the last week
and see how many you have resolved. Through time
and patience, like the sky after the storm.*

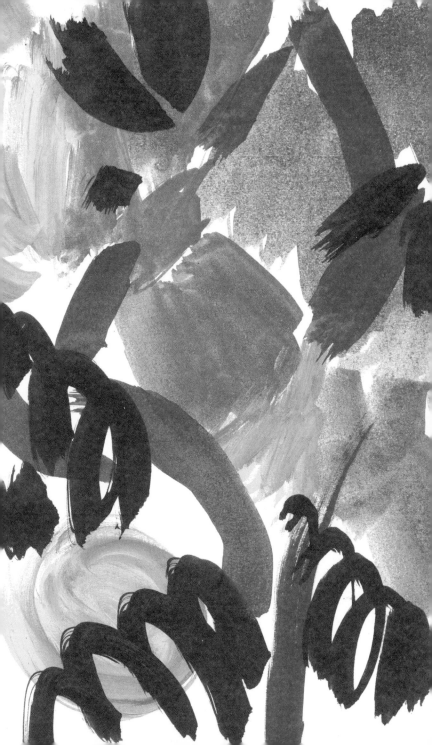

If you see, feel, and live attentively, you will find that there is so much inspiration, character, and wisdom hidden all around. Just waiting to be unfurled. Attention is the best gift you can give to someone and to yourself. A rare form of kindness.

Think about your own attention.
Is it the macro or the micro that draws you?

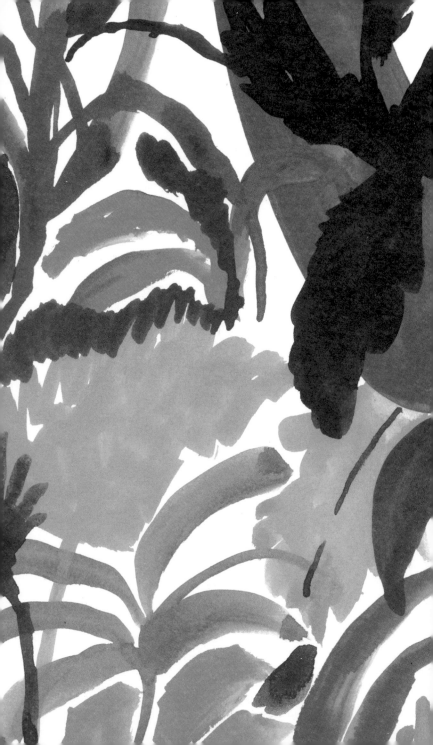

Seasons are nature's ways of pausing. May be to find balance and harmony? Like seasons, art rests in white spaces, commas in writing, and music is composed with rests. Pauses are the spaces with meanings.

List five areas where you pause consciously.
Does it bring any difference in the experience? If so,
try to illustrate it in abstract or figurative ways!

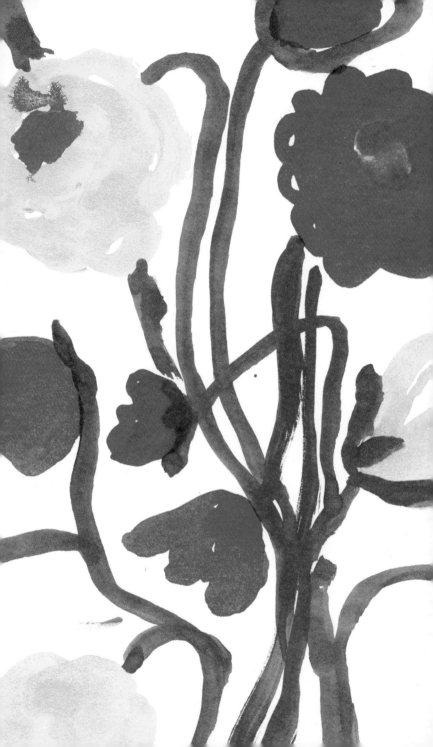

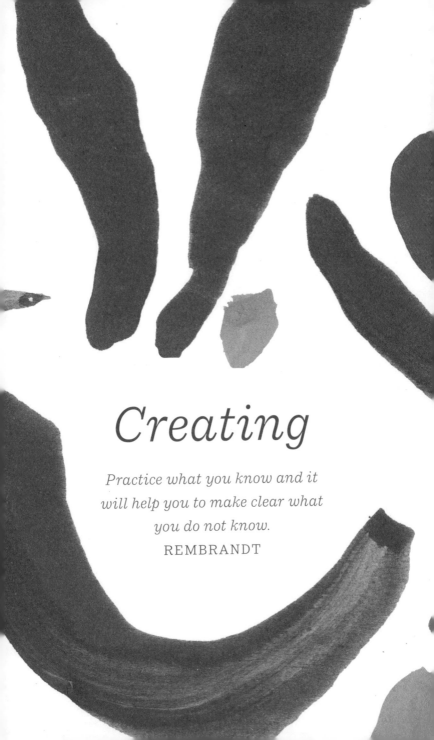

Creating

Practice what you know and it will help you to make clear what you do not know.

REMBRANDT

Have you ever considered if nature uses different colour palettes for night and day? Or for the seasons? Or a different set of brushes working way up through dusk and dawn. Or perhaps, where all these colours are stored? How are they refilled? Whatever and wherever it is, every version is soulful and seems flawless to the eye!

In a 1 inch x 1inch square, paint five colour combinations from nature around you in any medium. Now rejig this and see if you arrive at new combinations that speak more strongly to you. This is one technique that painters and designers use often!

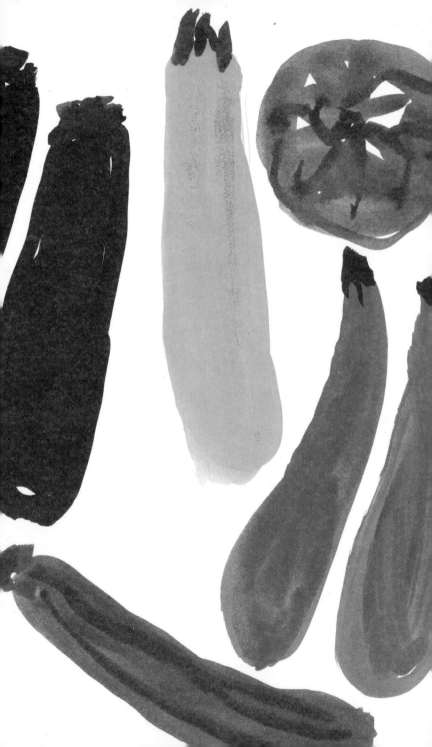

Rain doesn't wash away the colour.
Wind doesn't take away the fragrance.
The Sun doesn't take away the texture,
and the Moon only enhances the silhouette.
In nature, all the elements support and enhance
growth and life for each other. Isn't this the sort
of love and admiration we need too?

Think of an example of support from the life
around you. Can you portray this by creating
texture using a tool of your choice?

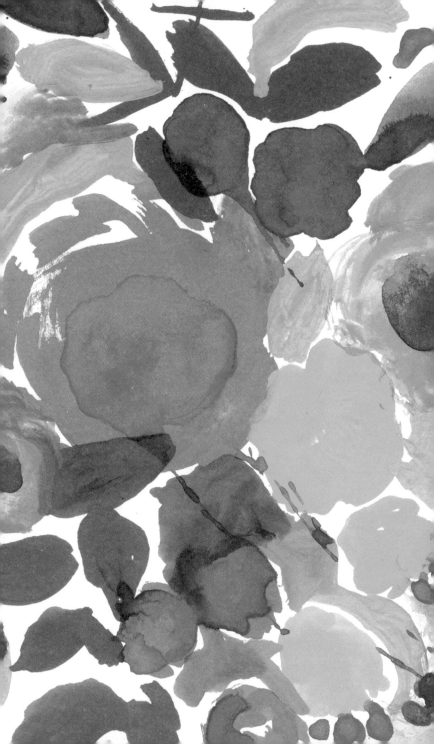

An old creeper in the winter. Naked and still, does it long for the warmth of the summer or the onset of spring to return to life?

Using a dry brush and ink, draw to understand the form of the dried creeper. The interplay of stems and varied thicknesses.

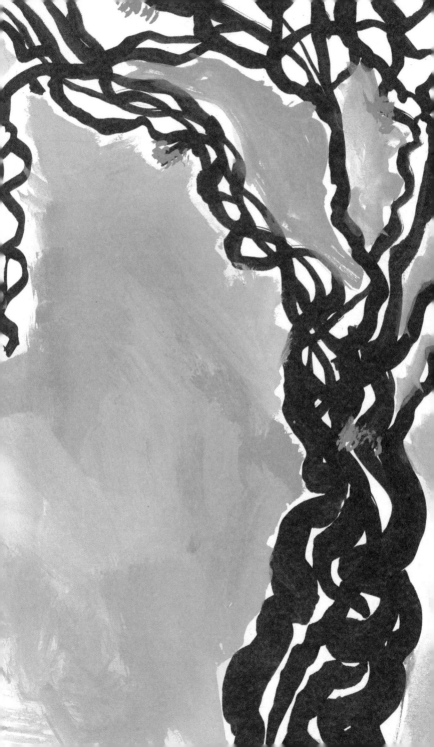

Does the day come before the night or does the night set before the day? Does an artist call themselves an artist before they create a work of art or does the work of art decide that one is an artist?

Think of your favourite artist and try to replicate any of their work. Observe the finer nuances of the piece and record your understanding at the end of it.

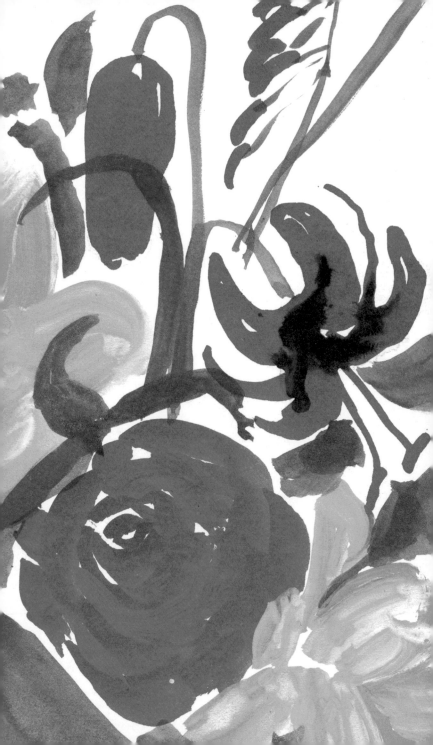

Have you ever wondered why plants, flowers, trees, birds, and other life forms vary in shapes, sizes, colours, and textures. Despite differences/contrast, all these elements work in harmony.

Can you visualize what you will wear today? Mix and match textures, colours, layers to arrive at a harmonious picture like nature!

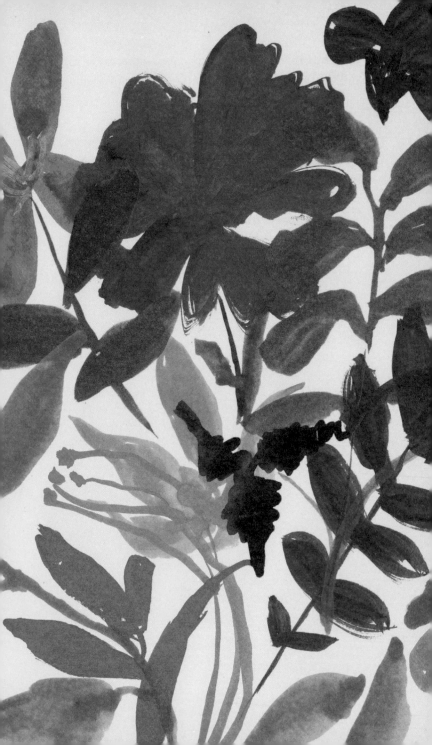

Look at a tree from the bottom. A pond from the top.
What if shifting the perspective brings new dimension to the
seeing? A dimension of clarity and a new understanding.

Take three photographs of a tall tree from different angles.
Zoom into the picture and see how different it feels.
Do you discover new forms in the zoomed-in version?
If so, try this exercise when you are in the nature again.
You may start seeing everything with a fresh pair of eyes!

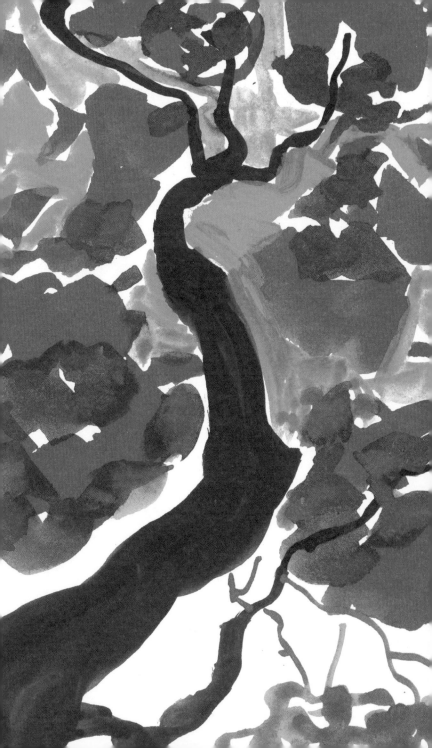

Small and wild, wildflowers bloom like colourful splatters
nature has painted to complete the look for the season.

*With a loaded paintbrush, try to splatter colour in
the space here to make your own wilderness. Repeat it
with two or three colours. Experimentation with mediums
and techniques offers unpredictable ways of seeing and
mark-making.*

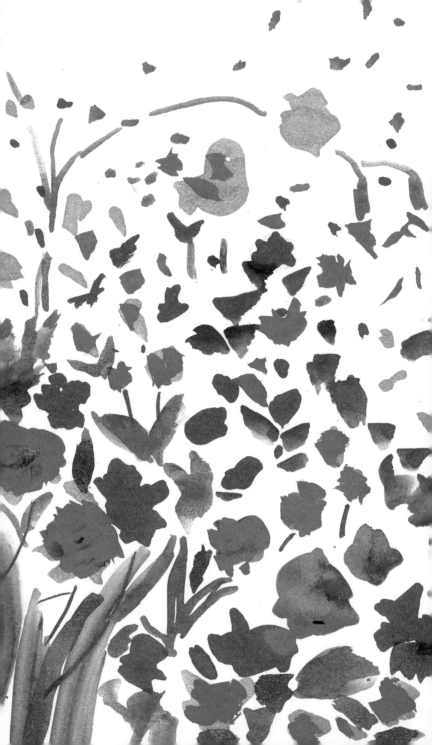

Does a flower bloom in order to be happy? Or a tree bears fruits out of happiness? Or the sky brings in a rainbow to make you smile? Giving with happiness is possibly the most satisfying gesture one can learn from nature. Does this selfless way of giving bring in strength to flourish?

Create something from this happy space for someone dear!

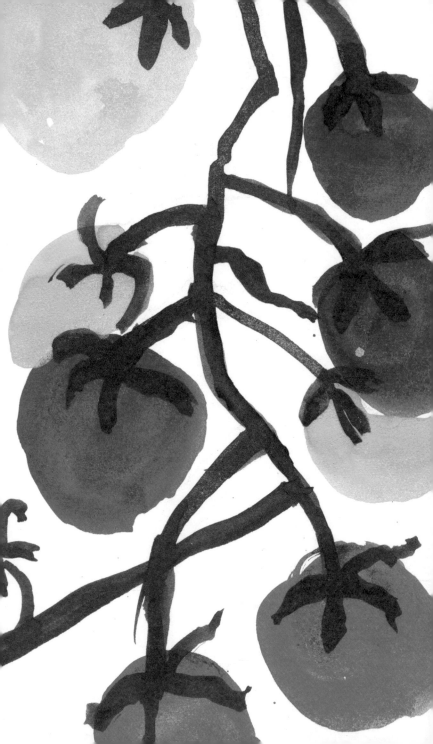

A new moon doesn't give up becoming a full moon. With slow strides each night, it turns into a glorious one. Staying committed is all about making progress in the darkness too.

Start something creative today. A piece to knit, embroider, paint and don't be afraid to mess it up. Just stay committed no matter how you feel about it. Try this for a couple of weeks and see how you feel.

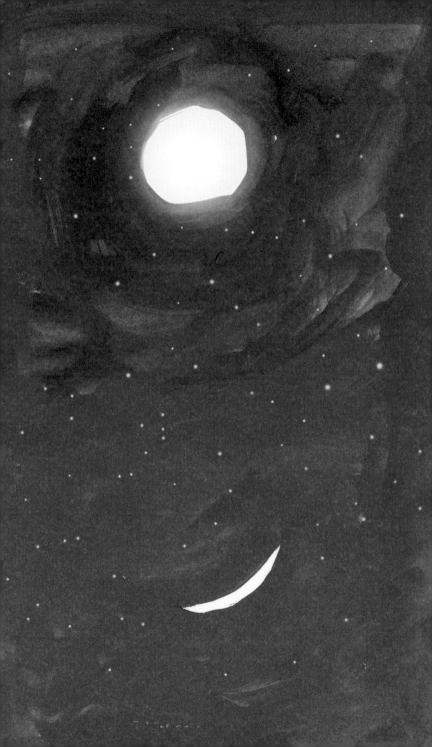

To understand the proportions in nature, embrace drawing as a way of understanding, seeing, exploring, and getting closer to it. Drawing is a pre-eminent relationship to align your head, hands, and heart. To observe and record.

Try to draw for five minutes daily, almost like a ritual. This can be on the breakfast table, on the train or the bathroom. Simple quick sketches. See if your imagination sharpens in any way!

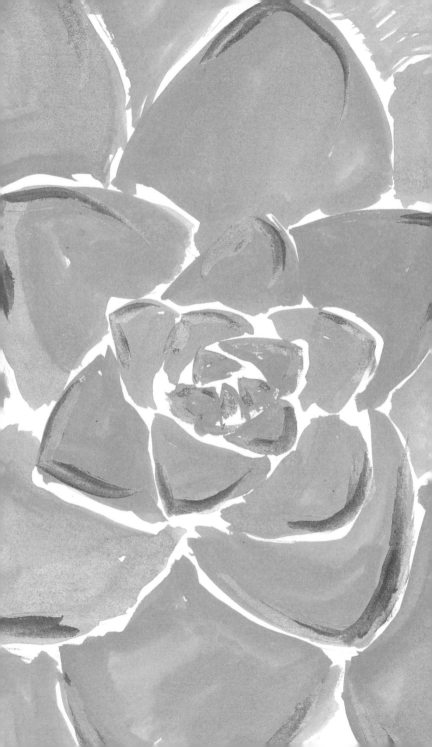

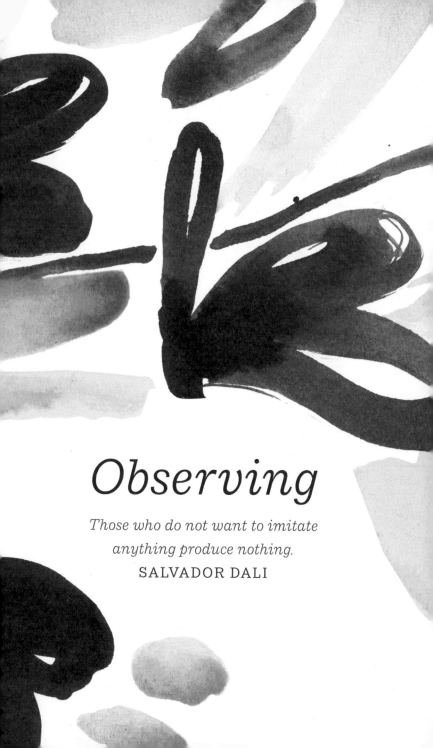

Observing

*Those who do not want to imitate
anything produce nothing.*
SALVADOR DALI

Darkness informs light. While you see the beautiful hues, textures, and geometry of flowers and leaves, have you ever paid attention to the darkness between dense dark bushes? A land of tiny details, tints, and shades. A land of wonder. Unseen and unfamiliar. Another form of beauty in undiscovered life forms. Maybe, that is where life happens.

Can you remember and name three such details/ instances from your past encounters in nature? Also note if you are able to think in colour.

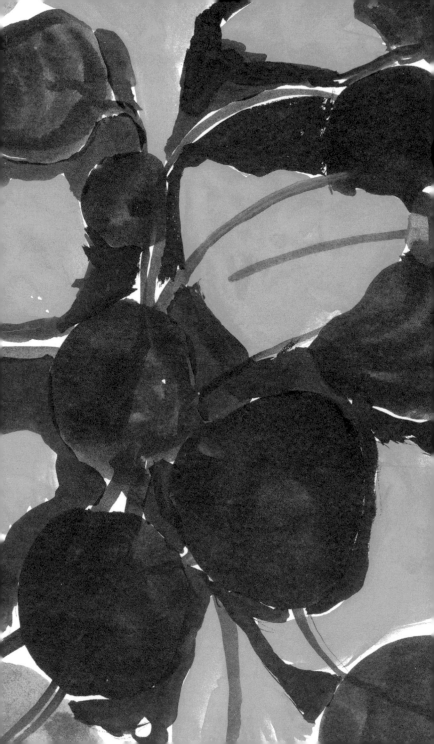

On a foggy morning, nature presents life in greyscale.
And through this, it assigns colour to all other life forms.
Greyscales can be visually ambiguous.
Can you embrace this ambiguity?

Close your eyes and take a few deep breaths. Try writing a few lines about what fascinates you the most in nature. Revisit the thought after a few days and see if anything has changed in the meanwhile.

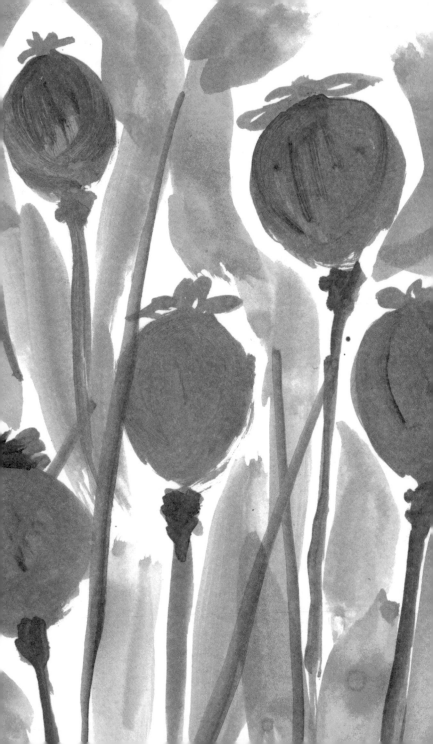

Let the world's imagination not cloud your magic of seeing today. Seeing something familiar with a fresh pair of eyes can be enchanting. For a long time. For a lifetime. Are the Sun and the Moon we see in the sky different each day? Or do we see them differently each day?

Draw and colour your favourite flower from three different angles. In doing so, try to observe and discover the hidden parts of the flower.

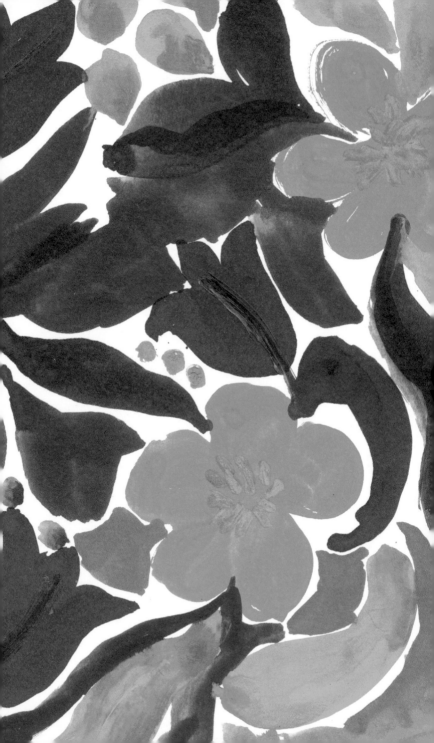

If you try not to capture the grass but interpret
the swaying of it, will you paint it differently?
Isn't it where lie the heart, life, and seeing?

*Observe the rhythm of the movement and try
capturing it in charcoal, watercolour or oil to
see the difference in its interpretation.*

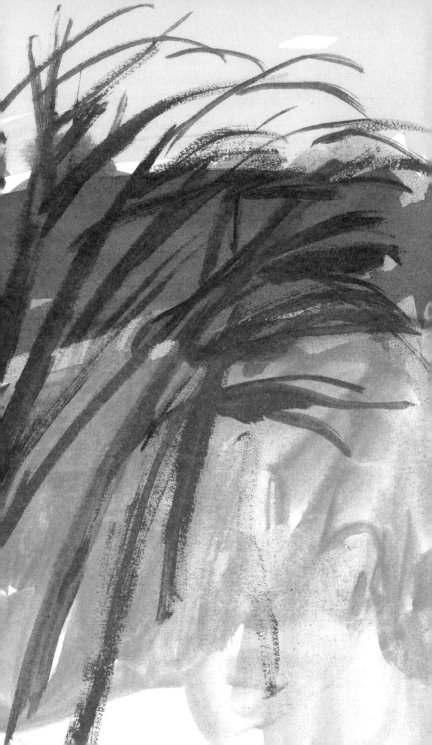

Do we ever wonder if the size of a flower matters?
Doesn't the fragrance, the colour, and the shapes of
its petals form its beauty?

*Make a comparative study by drawing three flowers
and leaves. Observe and record the differences,
for today and forever.*

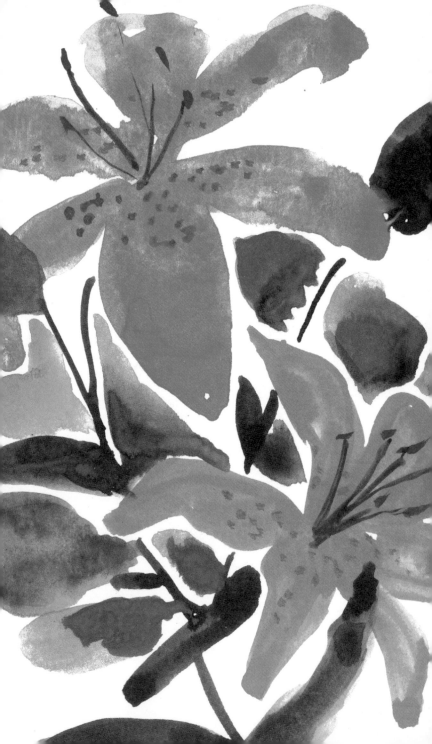

Even after a rough day, birds sing their song to settle at dusk. One of freedom, joy, and gratitude to mark the end.

Ends can be beautiful too, like the evening sun. Observe the shift in the light and how forms change to silhouettes offering subtle beauties.

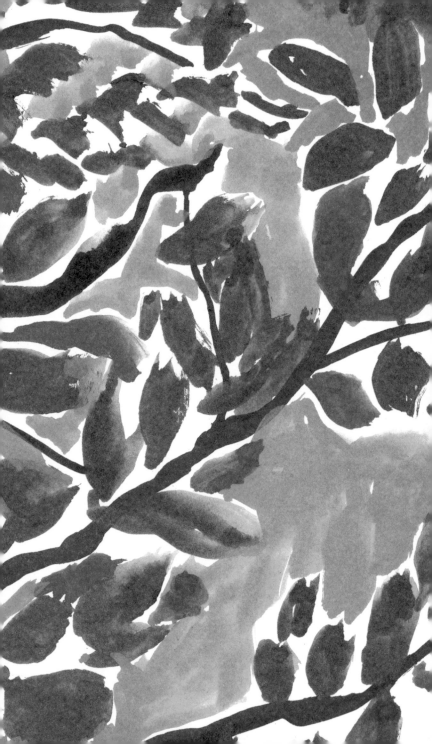

When nature is your companion, do you see the world in the same way? Does your way of seeing define your art or does your art define your seeing?

Make conscious efforts to mindfully see your environment. Record things that draw your attention. Try to further understand the reasons behind why things are the way they are and how they affect your experience.

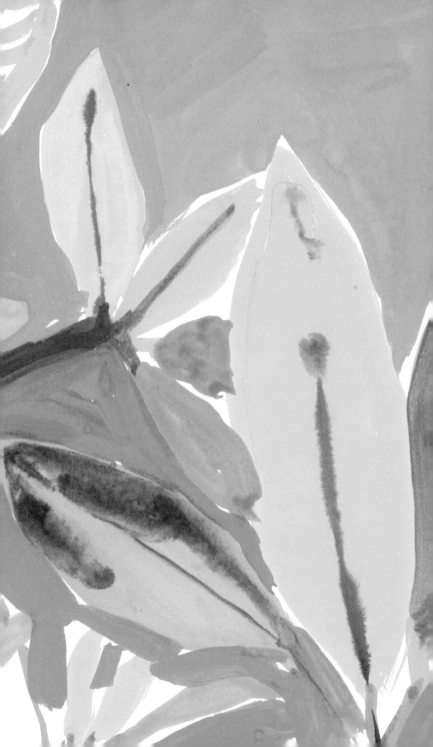

All trees may seem symmetrical from a distance, but from close quarters, each tree is unique in its asymmetry. Nature balances both symmetry and asymmetry effortlessly and gracefully. Do you think such kinds of imperfections break monotony in the most beautiful ways?

Look at a tree for a minute and try to absorb all aspects of form, colour, shape, shade, proportions, etc. Now, close your eyes and draw the same tree using a thick round brush. Once done, compare and make notes for yourself.

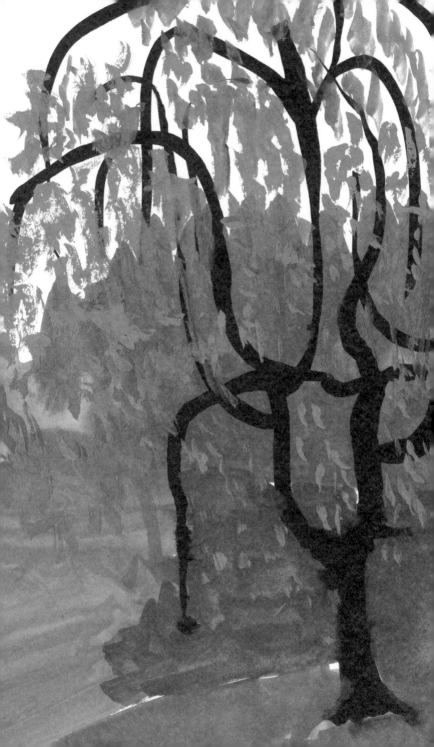

Does your seeing define your art or does your art
define your seeing?

Make conscious efforts to mindfully see your
environment. Record things that draw your attention.
Try to further understand the reasons behind why things
are the way they are and how they affect your experience.

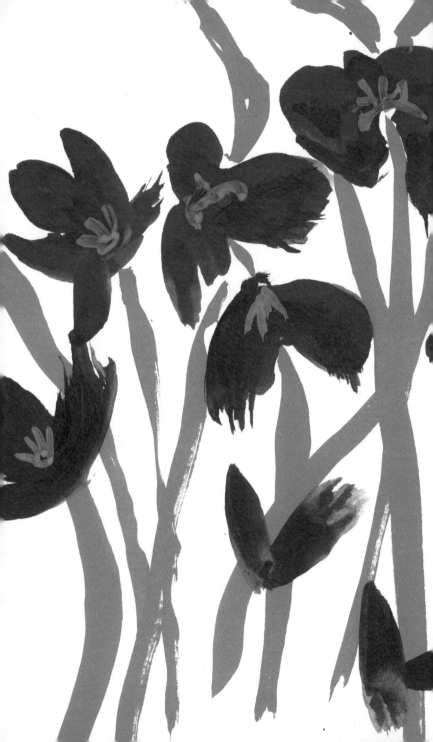

Does a tree grow giving equal importance to all its sides?
Or does it jostle through its own journey of life. One of
triumphs and tribulations.

*On your next walk, try to observe if this thought
holds true. Come back and reflect using your memory
through sketches or just scribbles in crayon.*

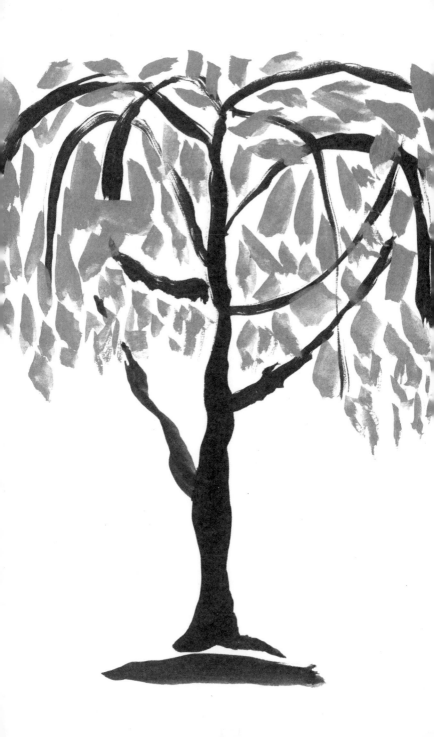

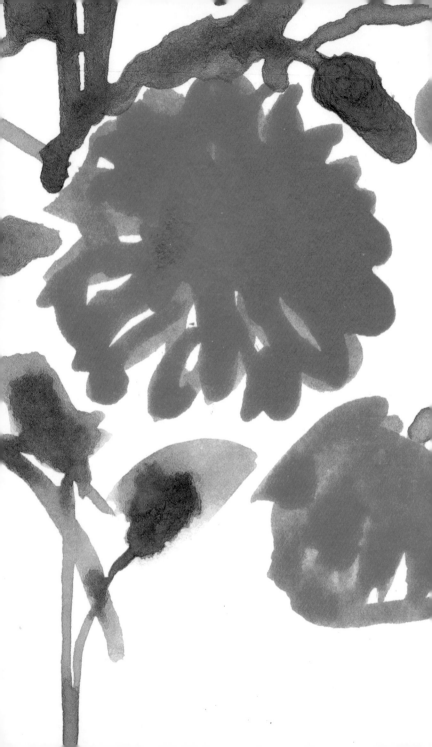

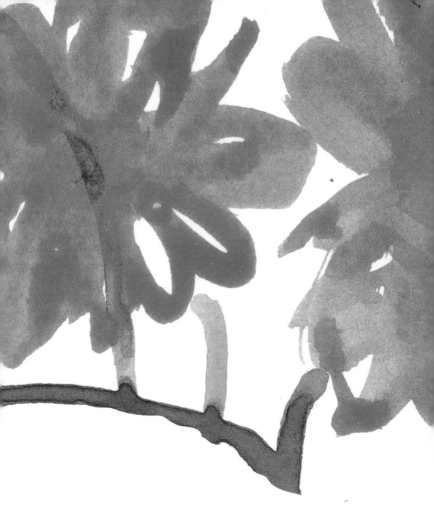

Perceiving

*How you draw is a reflection of how
you feel about the world. You're not
capturing it, you're interpreting it.*
JULIETTE ARISTIDES

Nature has its own language and ways of abstraction.
Recurring arrangements of patterns and stripes in
plants, fruits, animals, or algae on water.
It leaves much to the viewer for interpretation.
What you see is yours alone. Isn't this sort of viewing
most original and powerful in its form?

Draw a fruit and a vegetable with stripes on it.
Challenge yourself by assigning unusual colours to
the drawing and see how you feel about it.

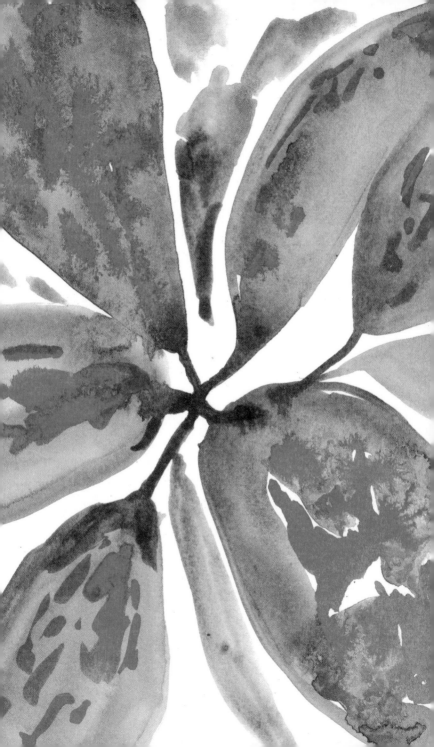

Slow is beautiful. It brings in new forms. New ways of contemplation and approaches. Adapt to the pace of nature—it grows silently all the time, day and night. And everything is achieved in the end.

Take a pause. Slow down and feel time passing by. Feel the breath going in and out of your body. Just be present in it and feel the difference.

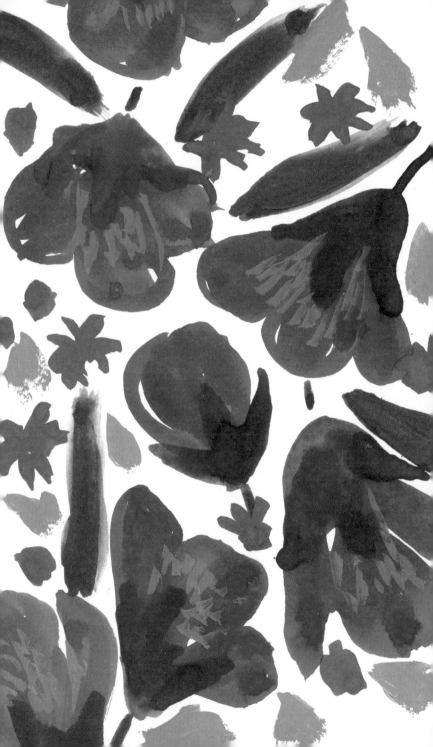

Murmuration is nothing but nature making
artworks in pointillism in the sky.

*Close your eyes and recollect a piece of
music that feels like murmuration.*

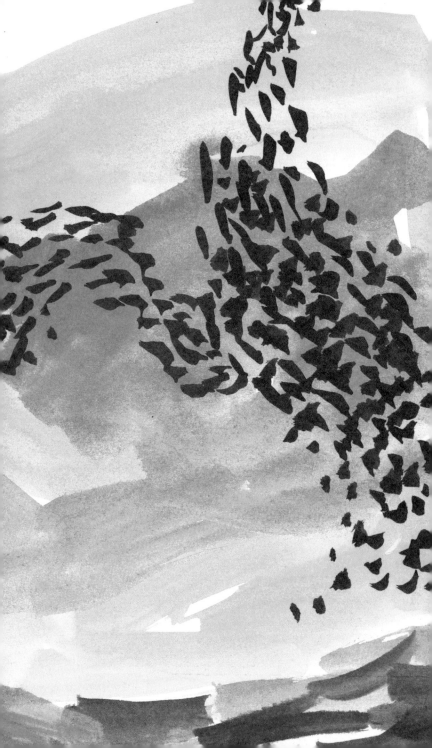

Silence has more power than we imagine. Even at its darkest, the silence of the night sky lets you see more. Feel more. Hear more. Have you felt a togetherness with silence yet?

Think of your relationship with silence.
Do you associate silence with any particular form,
colour, place or person? Does it enhance any aspect
of your personality?

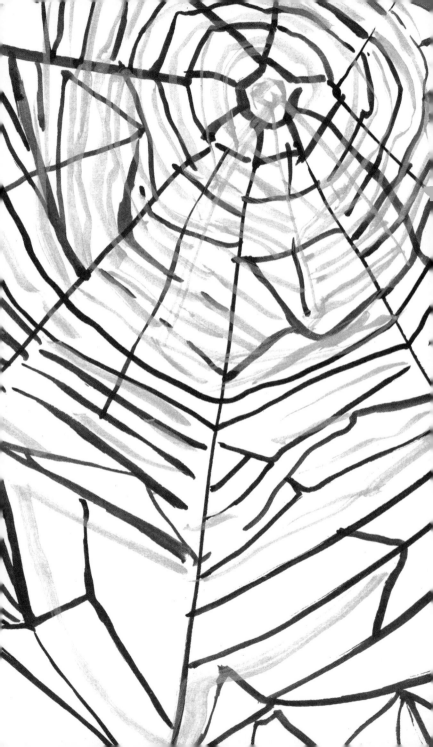

Who loves whom first? When you see a flower or night sky, or the night sky sees you. What if there is a notion of short togetherness between this seeing? How long does it last?

Next time you see a butterfly or a bird, try to capture it through drawing and see how much character you can record in that short togetherness. You may wish to focus on the general form first and then work in other details.

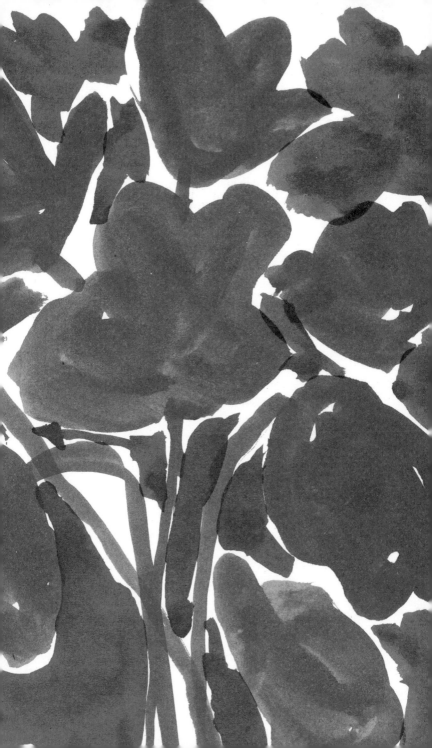

Remembering and recording are not necessarily achieved through the eyes. Feel the texture of asparagus in your mouth, walk on the misty morning grass bare feet. Do you think drawing these things would be the same or a different experience all together? Work up your way based on memory and intuition. Let them set the rules. You just play along.

Eat the asparagus and draw the forms and texture you felt in your mouth!

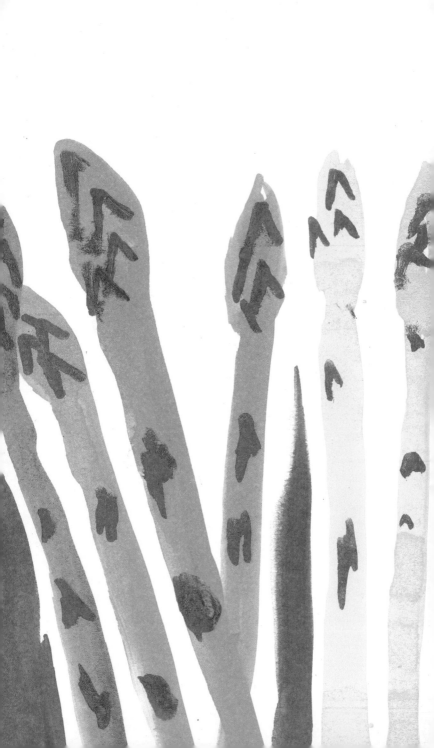

A farmer sowing seeds is such a measured relationship. A farmer knows when to give attention and when to leave the crops alone to grow. Just like for art, one needs to give time and attention to seeds for them to take shape. In this sort of giving, one truly learns the art of attachment and detachment.

Plant a sapling at home and see it grow. You may record the progress through a series of drawings. This will help you understand space, form, and structure in the changing visual form of the plant/tree.

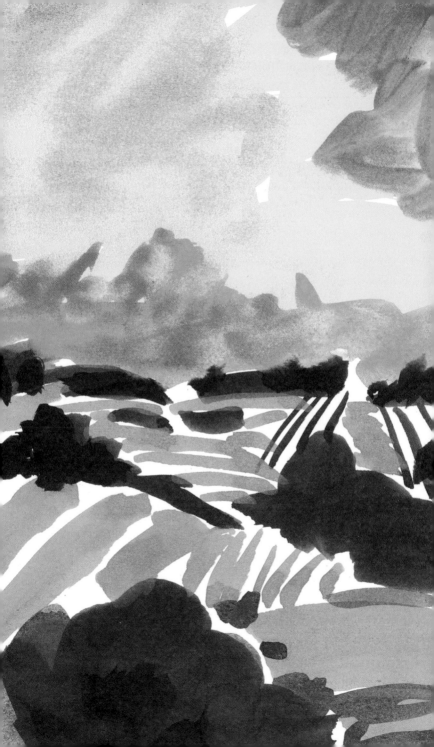

As spring sets in, new leaves and flowers arrive slowly and surely. One by one. Like a painter building up an image, stroke by stroke. Only one at a time. Of colour and thought. Of slow thinking and imagination.

Notice the ground when it starts raining. There are a few scattered dots. Then slowly and steadily the drops fill up the entire space!

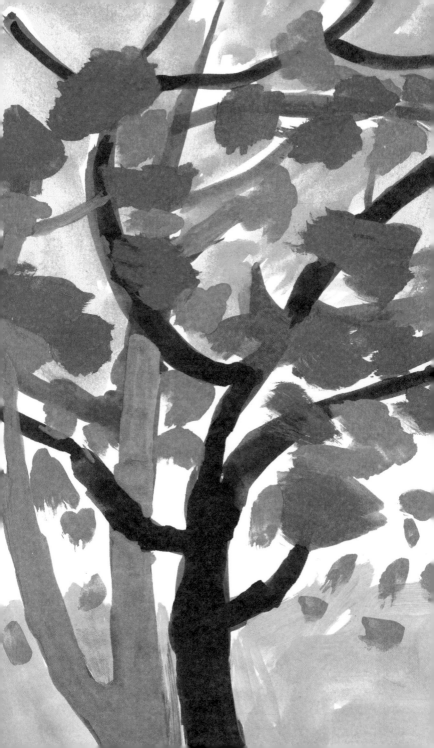

When you look at a tree, what do you see? Leaves in the foreground or the spaces in between. This difference in seeing makes all the difference.

Observe how your mind tries to complete the abstract shapes that you may find in the spaces. Try finding similar examples for a few days to understand the principle of closure.

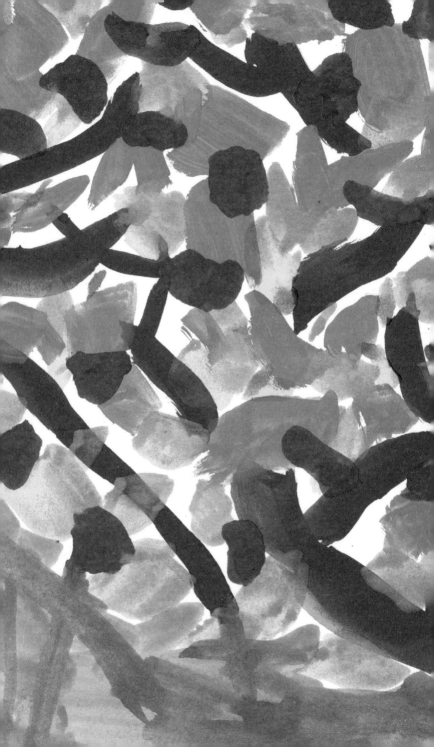

To make a change, you have to change. To enjoy spring, don't you have to pass through winter? Through rain to reach the rainbow? To shine, you have to burn. Like stars in the sky. Do you embrace the change, in life or at work?

Make a small artwork with ink and water and observe the change. Unpredictable forms emerge, offering something new to the eyes each time you look at it.

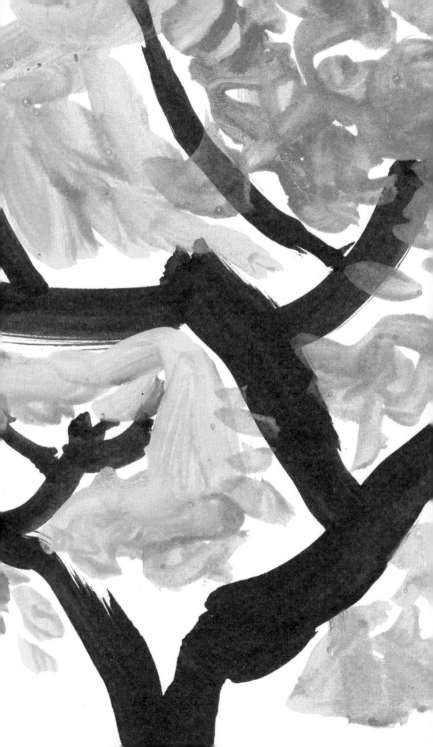

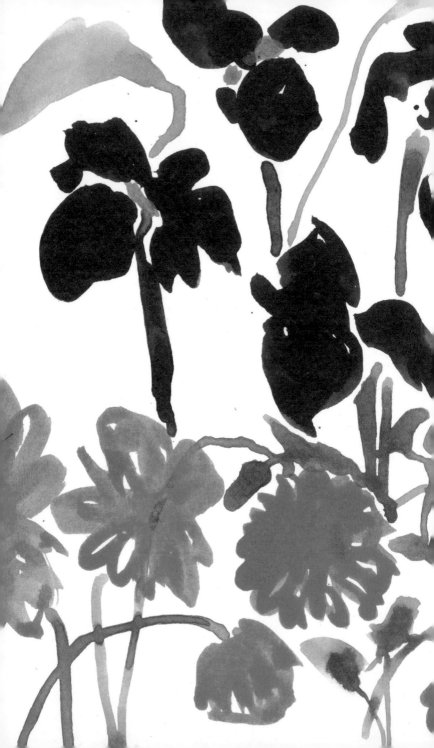

acknowledgements

My deepest gratitude to my publisher Meru Gokhale and my editor Rachel Rojy for all your trust, support, and encouragement. Binita Roy for polishing the text to perfection. Truly enjoyed making this book with you all and everyone at Penguin Random House, India.

Ranjit Hoskote. *Your generosity and grace is incomparable.*

Adrian Shaughnessy, Gulzaar Saab, Sharmila Tagore, Amitav Ghosh, B. N. Goswamy, and Ruskin Bond. *I feel blessed. Thank you so much.*

Mummy and daddy. Pushpendra and Shalini. *Without whom.*

Wg Cdr Alok Ahlawat. *Thank you for being.*

Special thanks to Roopal Kewalya. *My luminary for life.*

Wg Cdr Manju Bhaskar and Wg Cdr Sandeep Jaggi, Dr. Suman and Dr. Anil Panwar, Priyanka and Gp. Capt Pranav Raj, Priya and Virendra Singh, Simran Kaur and Gaurav Gupta, Shruti and Col. Prasad Mahajan, Lavanya Aggarwal, Richa Ghansiyal and Joshua Paljor Hishey, Arpita Nath, and Aparna Andhare. *Infinite gratitude!*

Tanisha and Tanishq. *Special hues in my life.*

Nonu. *For being storm on my painting table.*

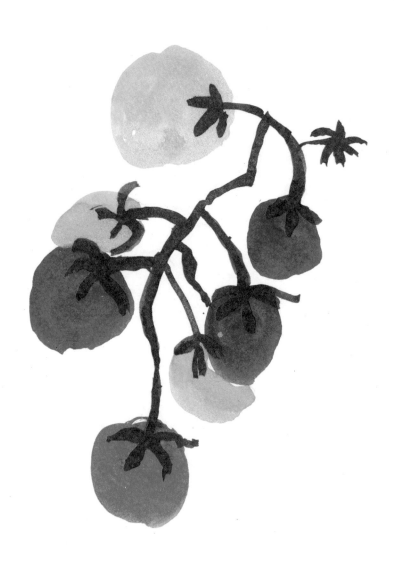

ahlawat gunjan

Multiple award-winning designer, self-taught painter, TEDx speaker, design educator—Ahlawat Gunjan wears many hats. A graduate of the National Institute of Design, Ahmedabad, he has a master's degree in graphic design from The Glasgow School of Art, UK. Ahlawat has also spent a semester at Indiana-Purdue University, USA, focusing on design thinking, innovation and leadership.

His overlapping interests in art and literature not only made him pursue a career in publishing but they also inform his keen interest in visual authorial interventions and curatorship. He strongly believes in the art and power of making and therefore himself constructs most of the images for his book covers.

Trained at Lars Mullers Switzerland and Faber & Faber, UK, Ahlawat has worked closely with Faber and Faber, Hachette, Little Brown, Hodder, Scribe, Quercus, Hurst, Pantheon and Knopf Doubleday USA.

Currently, he is Head of Design at Penguin Random House, India, and spends his free time painting. He has won numerous awards and accolades, including the Oxford Bookstore cover prize for *Gun Island* (2021) and the Atta Galatta Bangalore Literature Festival for *Rising Heat* (2020).

Slow is Beautiful is his first book. He lives in New Delhi with his piano and a room full of paints and brushes. He can be reached at ahlawatgunjan@gmail.com.

*A thoughtful homage to
mindful and beautiful living
through Ahlawat's visuals and words.
A must-have in today's digital age.*
RUSKIN BOND